IMAGES OF
EAST ANGLIA RAILWAYS

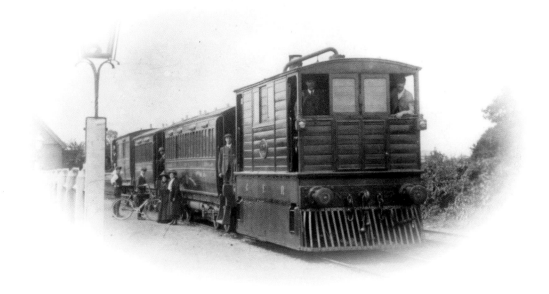

CLASSIC PHOTOGRAPHS FROM
THE MAURICE DART RAILWAY COLLECTION

HALSGROVE

First published in Great Britain in 2015

British Library Cataloguing-in-Publication Data
A CIP record for this title is available from the British Library

ISBN 978 0 85704 258 3

HALSGROVE
Halsgrove House,
Ryelands Business Park,
Bagley Road, Wellington, Somerset TA21 9PZ
Tel: 01823 653777 Fax: 01823 216796
email: sales@halsgrove.com

Part of the Halsgrove group of companies
Information on all Halsgrove titles is available at: www.halsgrove.com

Printed in China by Everbest Printing Co Ltd

CONTENTS

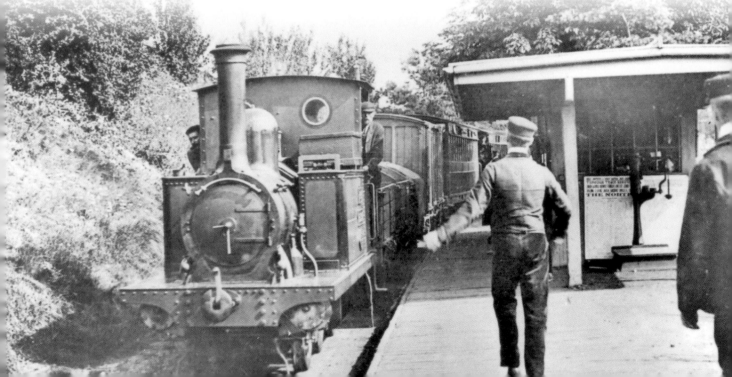

ACKNOWLEDGEMENTS

I express special thanks to my friends, Mike Daly and Denis Richards for permission to reproduce photos taken by them. Likewise I express thanks for permission to use photos which I have purchased from the collections of the Stephenson Locomotive Society, The Locomotive Club of Great Britain (Ken Nunn collection) and Rail Archive Stephenson (Photomatic). Also my thanks and apologies are proffered to other photographers whose work has been used and not credited. Where no credit is given the photographer is unknown. I also extend my thanks to Steve Jenkins for advice when describing some of the carriage and wagon stock. I am also indebted to Simon Butler of Halsgrove for suggesting the idea of this series of books.

REFERENCE SOURCES

A Detailed History of British Railways Standard Steam Locomotives. RCTS.
A Regional History Of The Railways Of Great Britain. Volume 5. The Eastern Counties. D. I. Gordon.
Austerity 2-8-0s & 2-10-0s. J. W. P. Rowledge.
British Locomotive Names of the Twentieth Century. H. C. Casserley.
British Railways Bridges & Viaducts. Martin Smith.
British Railways Stock Changes and Withdrawal Dates. 1948 – 1968. Michael McManus.
British Railways Tunnels. Alan Blower.
Clinker's Register of Closed Passenger Stations and Goods Depots in England, Scotland and Wales.
 1830 – 1980. C. R. Clinker.
Industrial Locomotives. Industrial Railway Society.
LMSR, LNER and BR Locomotive Allocations for various years. RCTS.
Locomotives of the LNER. Various parts. RCTS.
Official Handbook of Railway Stations etc. Railway Clearing House.
Passengers No More. Gerald Daniels and L.A. Dench.
Preserved Locomotives Of British Railways. Peter Fox & Peter Hall.
The Allocation History of BR Diesels & Electrics. Roger Harris.
The Directory of Railway Stations. R. V. J. Butt.
The Observer's Directory of British Steam Locomotives. H. C. Casserley
The Railways of Great Britain. A Historical Atlas. Colonel M. H. Cobb.
War Department Locomotives. R. Tourret.
My personal notebooks dating from 1945.

INTRODUCTION

At a very early age I was taken to Dockyard Halt, near Devonport and soon afterwards to St. Budeaux GWR station to 'watch trains'. I was taught to remember the names of three engines that passed through. At home there was a Hornby Gauge '0' model railway. Most Saturday afternoons my parents would take me with them from St Budeaux to either Devonport, reached by tram, or Plymouth, to which we caught a 'Motor Train' to Millbay. So my interest in railways steadily developed. During the summers of 1937, 1938 and 1939, the three of us spent a week travelling by train to Torquay, Paignton or Goodrington, with sometimes a venture to Kingswear and across to Dartmouth on the 'MEW' or to Dawlish Warren. We used a Family Holiday Runabout ticket for the week and set out from St Budeaux on an excursion train that ran daily from Saltash to Paignton and which, from memory, was usually hauled by a Castle class locomotive to Newton Abbot. From our front windows at Higher St Budeaux I was able to watch trains in the distance as they climbed towards the Devon side of the Royal Albert Bridge. They could also be seen as they rounded the curves west of Saltash station. I asked my father on one occasion why we did not go to Cornwall instead of to Paignton and he replied that it was better to go up the line. This was probably because there was a daily excursion train from Saltash to Newton Abbot where we had to change trains and cross over the footbridge. My father would bring home books about railways. They had been loaned to him for me to look at and they contained many photographs of railway subjects. During the Second World War, following the second batch of blitz raids on Plymouth when many schools were damaged, I was evacuated to Bude by train from Friary. I stood in the corridor for most of the way to "see where I was going" much to the consternation of the WVS ladies who were accompanying us. I recall seeing a tank engine, at what I later learned was Meldon Quarry, carrying 500S on its tank side. This was the T class 'Service loco'. Evacuation to Bude was followed by a short period back at St Budeaux after which I spent two years at St Austell, using trains to and from North Road. Whilst there, at the evacuated Grammar school, I met many older boys who were railway enthusiasts and my 'railway education' commenced properly.

My father had been transferred from Devonport to the Dockyard at Gibraltar during 1943, and in the summer of 1947 I went there by sea for a holiday for several weeks. We sailed from and arrived back at Southampton Eastern Docks to and from which a Boat train was available from Waterloo. My mother travelled to Paddington with me and took me to Waterloo for the afternoon departure. She met me on my return and we spent the night staying with a relation near Waterloo. The next day I was taken briefly to London Bridge, Charing Cross, Victoria, Kings Cross, St Pancras and Euston before we departed from Paddington on the 3.30pm to Penzance. So my introduction to the London area had commenced. My father was an amateur photographer and he taught me to use a box camera. I immediately started taking photographs of Gibraltar Dockyard locomotives from a balcony!

On returning to St Budeaux I found my father's two old cameras and managed to obtain a film for each. A large folding Kodak that used A-122 film turned out to have a pin hole in the bellows, only discovered when the results of the first film were seen. This made it unusable. The other was an old Box Brownie which had a push-over lever shutter release and had one good and one faulty viewfinder that showed two images, one above the other. I persevered with this but did not know enough to achieve much success. I tried to record trains passing through St Budeaux and went to Laira shed late in September and took photos, some against the low evening sun. Still, we all had to learn by experience. With those which I had taken at Gibraltar, this was the start of my collection of railway photographs. I saved my pocket money and managed to go on a few Saturday trips to Exeter and as holiday treats I was allowed to make trips to Bristol and Salisbury. In 1946 my mother accompanied me on a trip to Cardiff and waited outside whilst I 'bunked' around Canton shed. In December 1947 I did a day trip to Gloucester. In January 1948 my mother and I joined my father in Gibraltar which involved sailing from and to Liverpool. On returning home as time progressed I was able to buy better cameras and commenced longer railway trips to places further afield. Apart from visiting loco sheds at Stratford, Devons Road and Plaistow I did not venture into East Anglia until 1972 when a BR 'Mystery Trip' from Plymouth worked to Southend Central. After a few more years my visits to the area became more frequent and after several years I began to discover the wide range of preserved lines which operated. My railway interest widened from purely collecting engine names and numbers to encompass signalling and railway history. This was progressed by meeting more very knowledgeable older railway enthusiasts and railwaymen, many of whom became lifelong friends. I developed a desire to obtain photographs of some of the locomotives that I had seen in my early years, so the process of searching for and purchasing photos commenced. As my interest and knowledge grew, so likewise did the quest for more photos. This now encompassed all of Devon and Cornwall and large sections of Wales, along with various classes of locomotives from all over the country. I commenced travelling on as many routes as money and time permitted which covered the Home Counties and other areas. An interest in Narrow Gauge and Industrial railways developed. So the 'Archive' steadily grew from filling an expanding suitcase to occupying a considerable expanse of shelf space in two rooms and a drawer. When it was suggested that I compile some books making use of some of these images I thought that it would be a great idea as many of them, to the best of my knowledge, had not previously been used in publications. Previous books covered the south west and other areas of the country. This is not an attempt to include every location or type of locomotive that has worked in the area but is simply a selection from my collection. As the photos have been collected by me personally my own particular interests and likings for certain locomotive types are reflected by some sections containing larger numbers of photos than others.. As well as photos of the well known large express locos I have concentrated on including shots of smaller, lesser photographed types and most of the preserved lines. Unusually there is a section showing Diesel and Electric Multiple Units but this is primarily to include some interesting locations not normally visited by passenger trains. Some older historical items are included, some of

which are not photographically perfect but merit inclusion because of their content but I have attempted to give a good overall coverage of the area from before the 1900s to the present day. These images may be of great interest to modellers of historic locomotives with period layouts. East Anglia comprises Hertfordshire, Essex, Huntingdonshire, Suffolk, Norfolk and Cambridgeshire together with north east and east London. Surprisingly, owing to the east to west elongated shape of Hertfordshire a section of the North West main line from Euston falls within its boundary so is included. The inner city is not included. Locations of places in Counties are as recorded in the RCH Handbook of Stations dated 1938. I have attempted to make the captions detailed without delving too deeply into railway history or becoming too technical. As this book features images from my personal collection, the layout follows the order in which the collection is arranged. This follows locomotive wheel arrangement and types from the largest downwards in decreasing order of size, with a few exceptions. It is a system that was used in the past by several notable authors that presents a markedly different layout to the now standard practice of following routes geographically. Readers seeking photos at specific locations should refer to the index at the end of the book. Any errors that are discovered are purely attributable to myself. I trust that within the contents there is material to cater for most railway interests and that memories of a bygone age will be recalled.

Maurice Dart
St Austell 2015

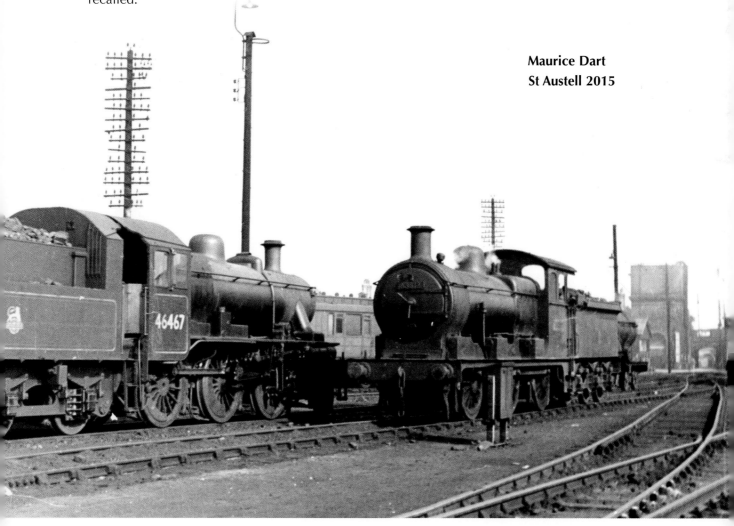

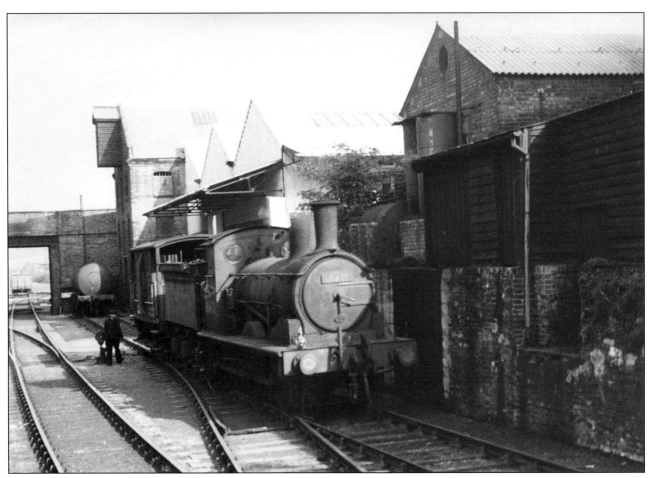

J15 class 0-6-0 65477 (ex 7549) from Cambridge shed shunts the siding at Saffron Walden on 22 September 1956. H.C. Casserley

1

AN 0-10-0T, 2-8-0s AND AN 0-8-0

The 0-10-0T was an experimental loco for working tightly timed local passenger services. 2-8-0s and 0-8-0s worked freight traffic.

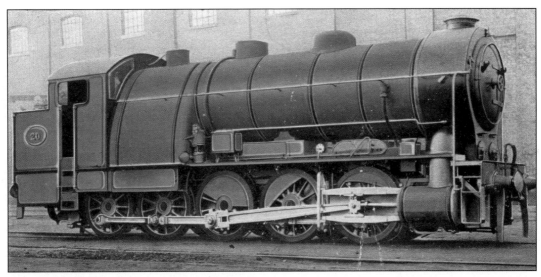

In 1902 the Great Eastern Railway constructed this huge 0-10-0T loco 20 which weighed 80 tons. The purpose was to prove that steam hauled suburban passenger trains could accelerate as fast as those worked by electric traction. The trials were successful but the loco was so heavy that much damage to the track was caused. It was considered that above the cost of the locos the additional expense incurred in up-grading the track was not justified so nothing further took place. In 1906 this 3-cylinder loco was rebuilt as a 2-cylinder 0-8-0 tender loco which worked Goods traffic until it was withdrawn from service in 1913. The loco is in its original form at Stratford shed in the early 1900s. The Knight Series

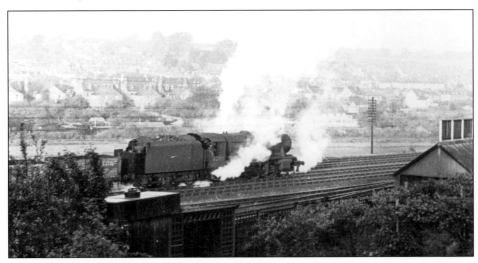

Crewe South's filthy LMS 8F 2-8-0 8310 slowly moves a freight out of Berkhamsted station past the Goods shed in the late 1940s.

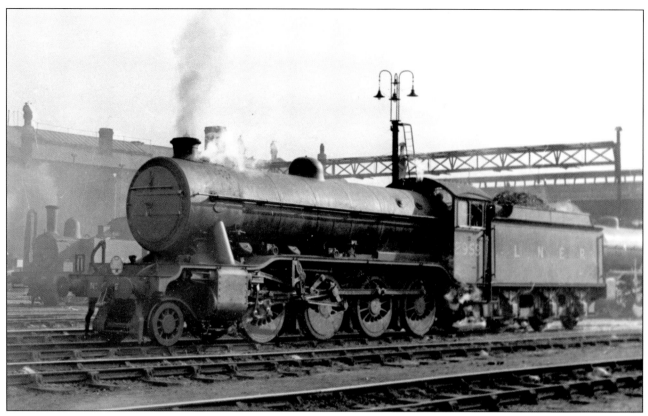

On 20 March 1938 March shed's O2 class 2-8-0 2959 (later 3952) is ready to go off shed at Stratford to go to Temple Mills yard to work a train north.

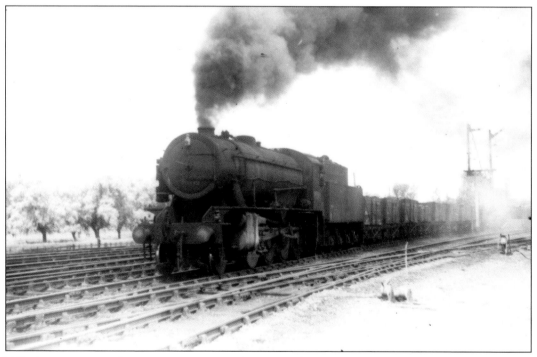

WD 2-8-0 70842 (later LNER 3064 and 90064) from New England shed, Peterborough approaches Cambridge Junction, Hicthin on a Down freight in 1946. Maurice Dart collection/ Transport Treasury

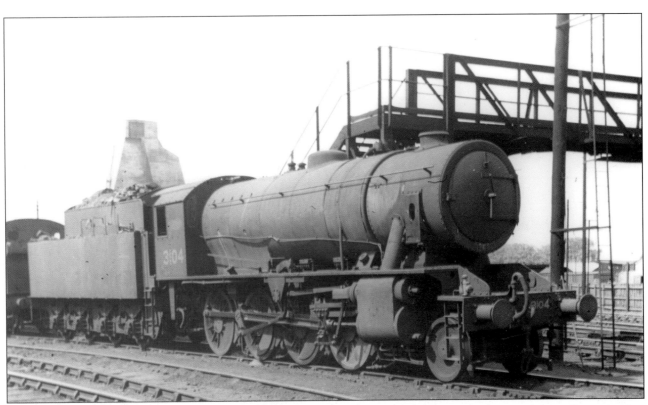

WD 2-8-0 77100 on loan to the LNER running as O7 class 3104 (later 90425) shedded at March is on shed at Cambridge in May 1947. L. R. Peters

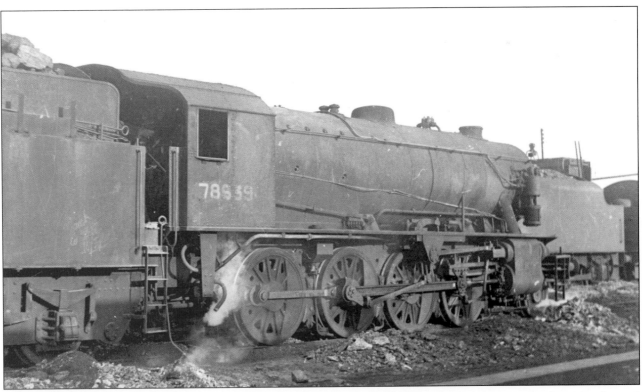

WD 2-8-0 78639 which became LNER O7 class 3133 and later BR 90454 is at home on shed at March on 6 April 1946.

WD 2-8-0 70805 fitted with a Westinghouse pump is at Royal Albert Docks in October 1946 following overhaul at Woolwich Arsenal. It is awaiting shipment to India where it worked on the Kowloon-Canton Railway as their No.23 until withdrawal took place in August 1959. E. Foster

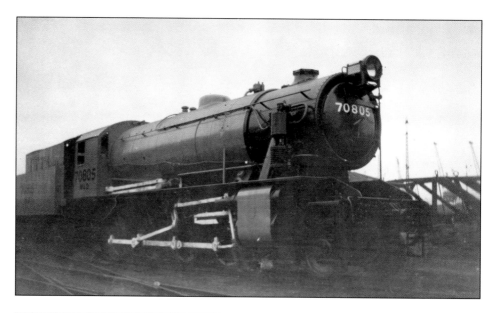

Wellingborough shed's WD 2-8-0 7156 (became 77156) works a freight through Berkhamsted on 11 May 1944. After working on the SR this loco became Netherlands Railway No.4481.
H. C. Casserley

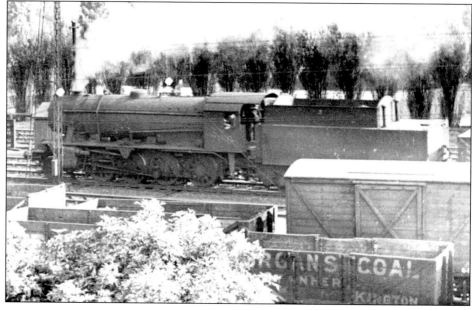

Willesden's G2A class 0-8-0 49344 loiters in the yard at Watford Junction in the early 1950s.

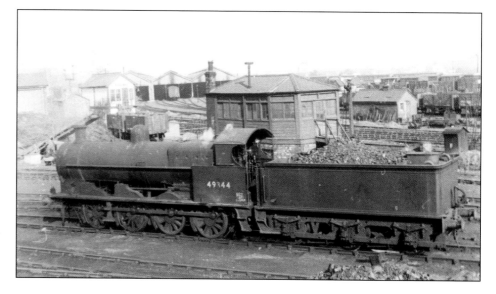

2

4-6-2s AND 4-6-4 TANKS

The Pacifics worked main line passenger trains and the 4-6-4Ts were used on fast passenger trains to Tilbury, Southend and Upminster.

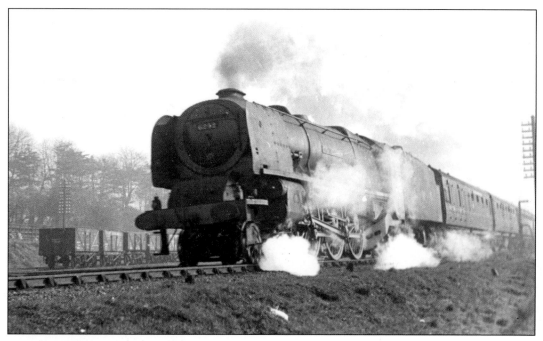

Camden's Princess Coronation class Pacific 6242 CITY OF GLASGOW works though Berkhamsted with a Down express on 29 February 1948.

Grantham allocated world famous record-breaking A4 class 'Streak' 4468 (later 22) MALLARD is in Cambridge shed yard around 1945. This loco has been preserved. In the right background is Lincoln's K3/2 class 2-6-0 73 (later 1822).

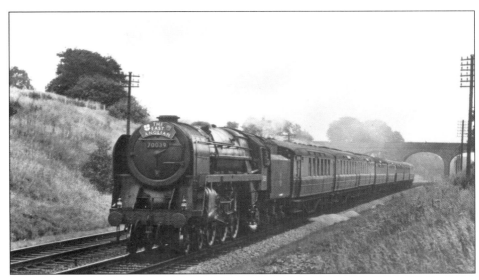

Early in 1953 Norwich allocated Britannia class Pacific 70039 SIR CHRISTOPHER WREN climbs Brentwood Bank with the Down 'East Anglian' express from Liverpool Street to Norwich. British Railways

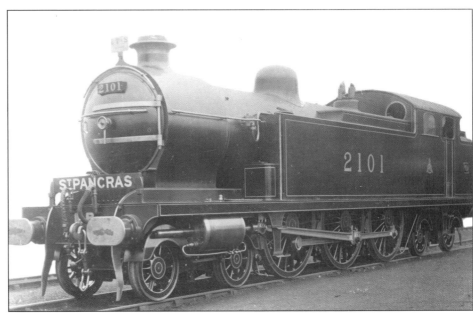

LTS Whitelegg Baltic 4-6-4T 2101 (later 2193) shortly after delivery in 1912 on display for a record photo at Bow Works. The loco was withdrawn before 1930 ended.

Whitelegg LTS Baltic 4-6-4T 2196 (ex 2104) at Plaistow shed around 1929. This loco had been withdrawn before the end of 1930. Real Photographs

3
LMS 4-6-0s

These worked express and intermediate passenger services.

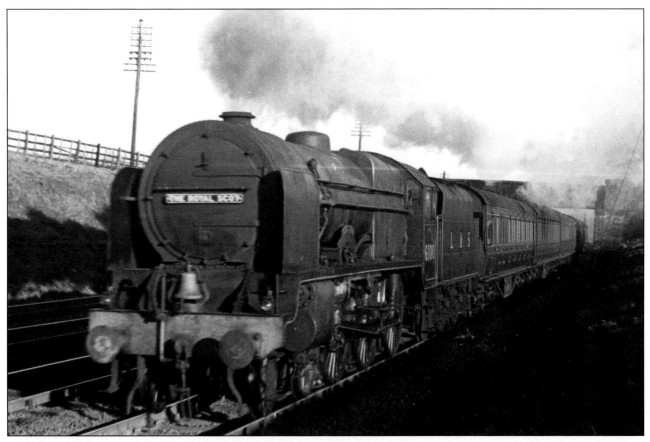

Camden's Royal Scot class 6100 ROYAL SCOT passing Northchurch hauling 'The Royal Scot' express on 17 March 1948. However all is not what it appears. In 1933 when 6100 was in Crewe Works and 6152 THE KING'S DRAGOON GUARDSMAN was ex-works in immaculate condition, the two locos changed identities.
H. C. Casserley

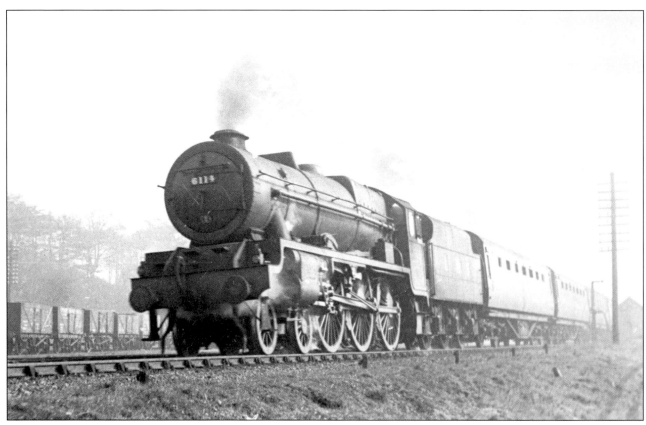

Longsight's rebuilt Royal Scot class 6114 COLDSTREAM GUARDSMEN works an express past Berkhamsted on 29 February 1948.

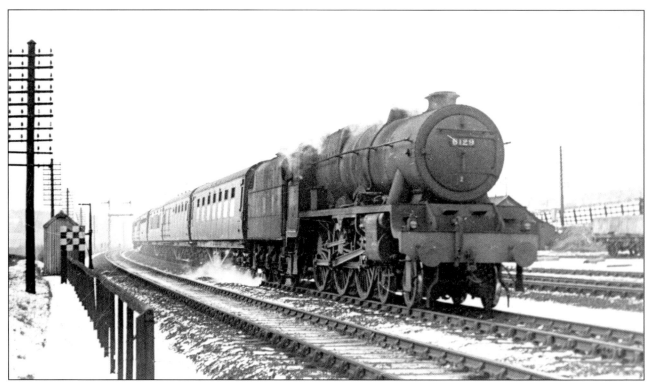

Rebuilt Royal Scot class 6129 THE SCOTTISH HORSE from Longsight shed passes Berkhamsted on an express on snowy 29 February 1948. This loco had previously been named COMET.

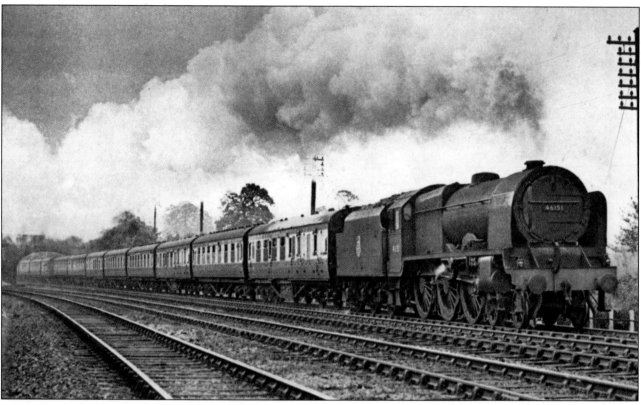

Royal Scot class 6151 THE ROYAL HORSE GUARDSMAN from Crewe North shed heads north on 'The Welshman' express near Kings Langley in the mid-1950s. British Railways

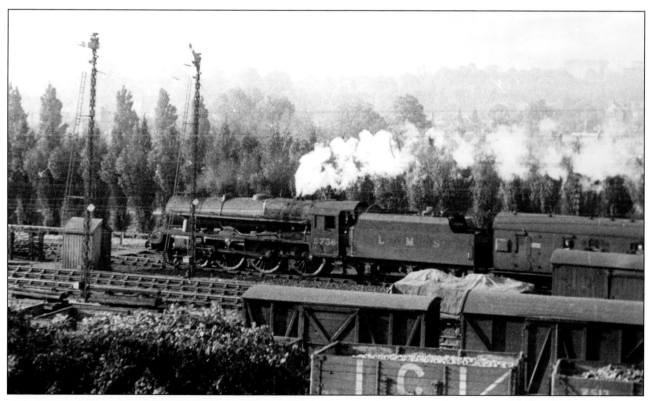

Camden's Jubilee class 5736 PHOENIX takes a passenger train through Berkhamsted on 18 May 1945. In the yard in the foreground is loaded ICI Private Owner wagon 1631.

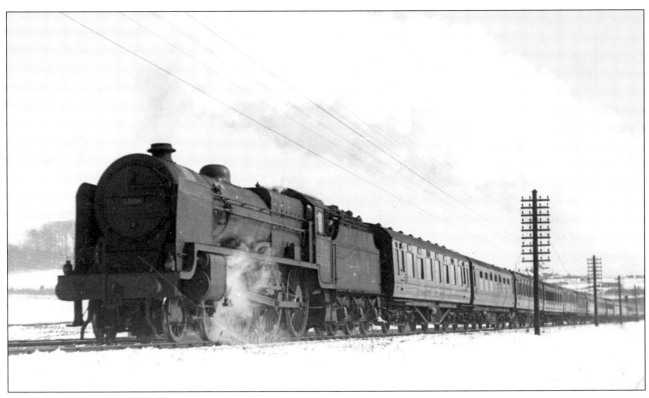

On snowy 7 March 1947 Carlisle Upperby's un-named Patriot class 5506 approaches Berkhamsted on a Down express composed of at least thirteen carriages.

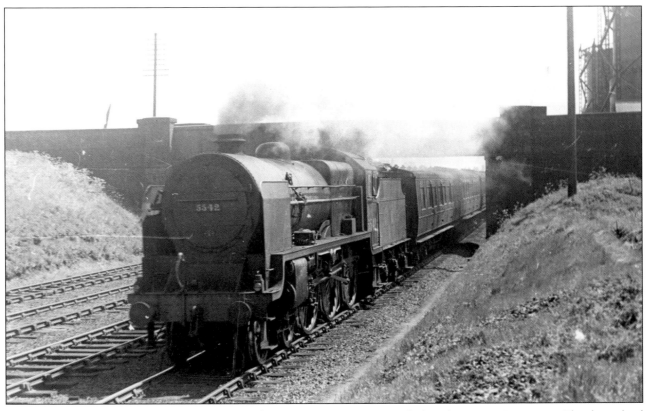

Crewe North shed's Patriot class 5542 heads an Up express at Northchurch on 8 May 1948. The loco had formerly been named DUNOON.

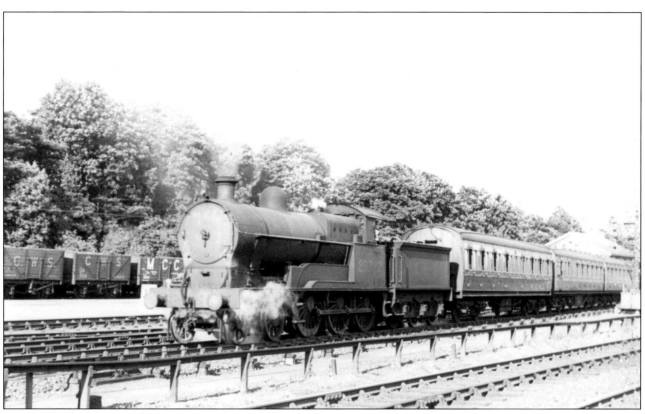

Prince of Wales class 25722 departs from Berkhamsted on a Stopping Passenger train on 14 July 1937. This loco which appears to be carrying a 2E (Warwick) shedplate was withdrawn during 1948.

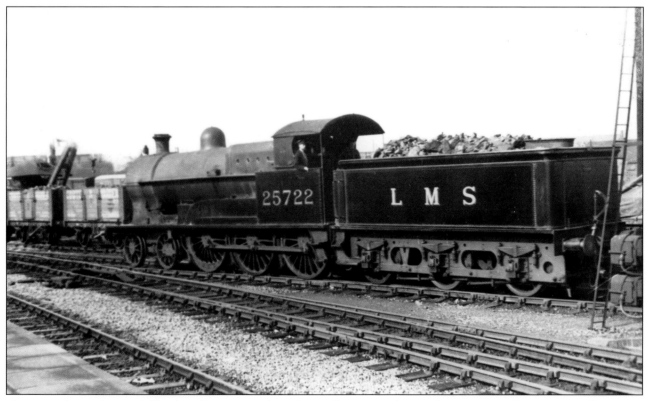

The same loco, Prince Of Wales class 25722 has obviously received a Works visit since the previous photo was taken and has been repainted. It is shunting at Cambridge on 20 May 1938.

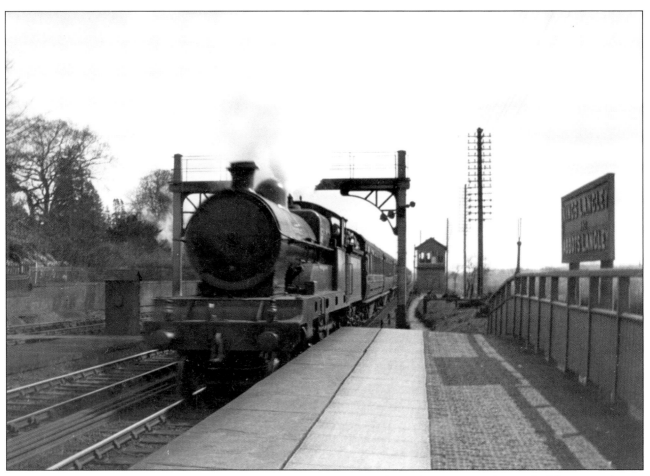

An unidentified member of the Claughton class heads an express through Kings Langley and Abbots Langley in the 1930s.

4

NER 4-6-0s

These locos were mainly to be found working passenger and parcels trains.

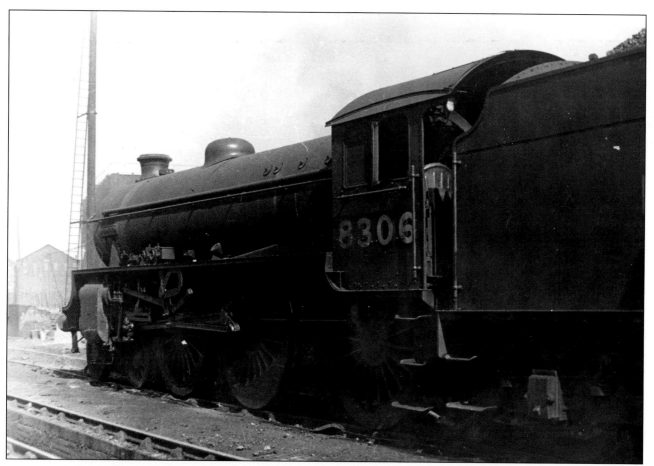

Stratford's B1 class 8306 (became 1005) BONGO loiters in the yard at its home shed on 4 August 1945.

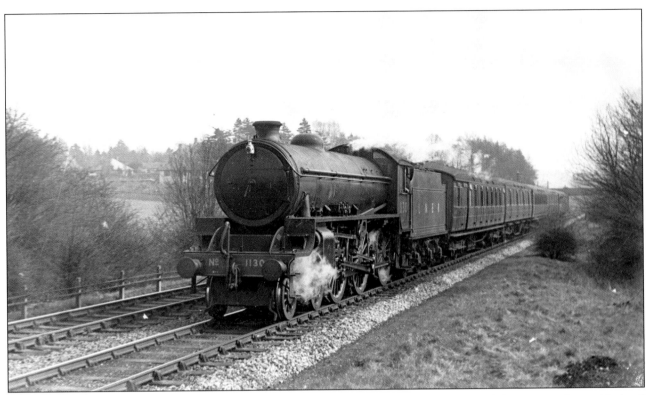

Leicester (G.C.'s) fairly new B1 class 1130 heads a Stopping Passenger train near Rickmansworth on 12 April 1947.

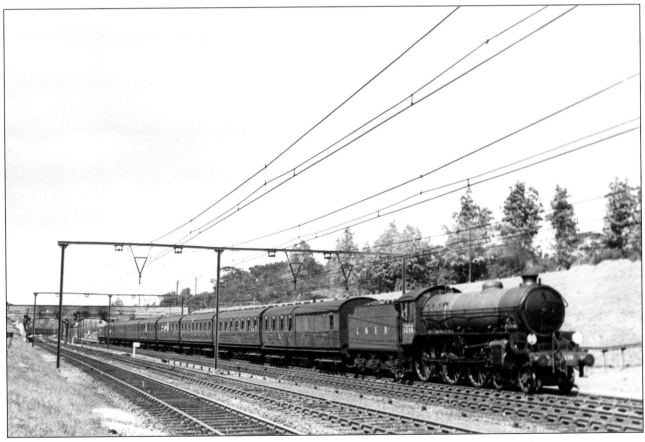

Stratford's clean B1 class 1236 approaches Shenfield with a Down express on 26 June 1948.

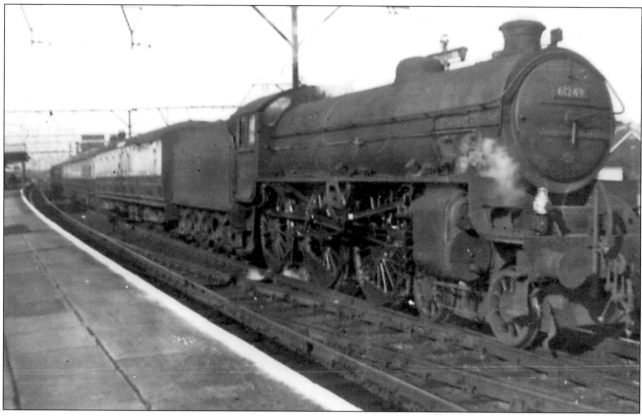

Early in 1959 Parkston shed's B1 class 61249 FITZHERBERT WRIGHT is stopped at Shenfield with a Harwich to Liverpool Street train. Ivor Cause.

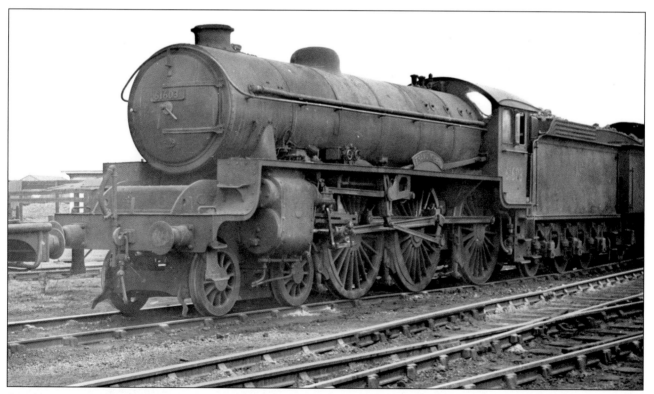

B2 class 61603 FRAMLINGHAM rests at home in the shed yard at Colchester early in 1950. This loco had been rebuilt from B17 class 2803.

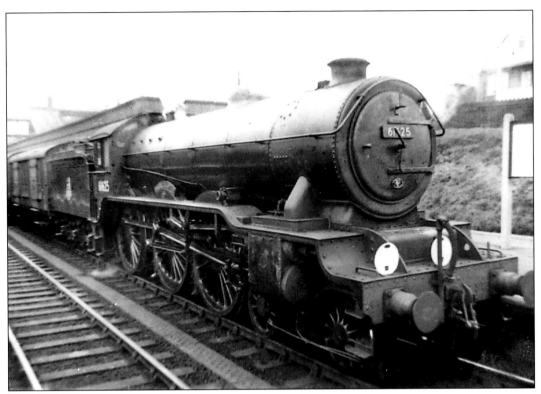

B17/2 class 61625 (ex 2825) RABY CASTLE from Ipswich shed is at Witham on a Liverpool Street to Colchester train early in 1959. Ivor Cause.

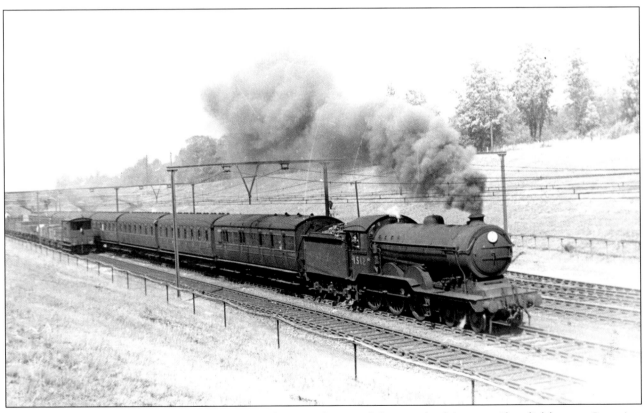

B12/3 class 1512 (previously 7426, 8512 and 1512) from Colchester shed is near Shenfield on a Stopping Passenger train on 20 June 1948.

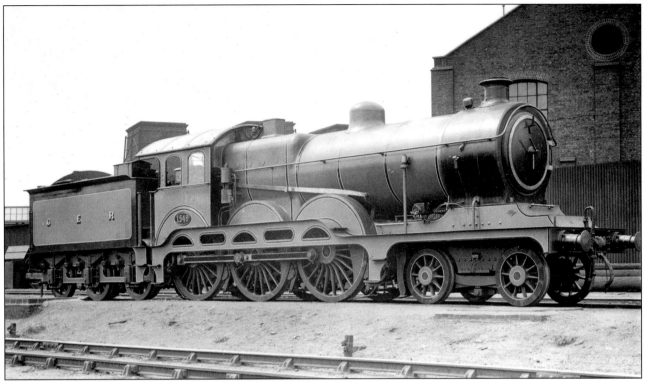

At home at Stratford in the early 1920s is B12 class 1549 (later 8549 and 1549) which was rebuilt to a B12/3 class in January 1944. This loco was allocated to work on the U S Army's Ambulance trains after D Day and was based at Templecombe. I saw it just west of St Austell at Trenance Junction at 2.50pm on very wet 10 June 1944 heading the train to Falmouth Docks when it was piloted by GW 4300 class 2-6-0 6330 from St Blazey shed. It was to transport returned wounded soldiers to hospital. The locos were serviced at Truro shed before collecting the train to return east. This was my first sighting of an LNER loco.

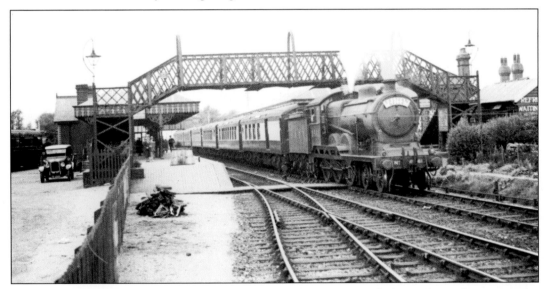

B12 class 8561 (ex 1561 and again later) awaits departure south from Sheringham with the 'Eastern Belle' Pullman excursion train in the early 1930s. The loco was converted to B12/3 class in 1937. This train, which commenced operating in May 1929, ran to a different destination on each day, apart from Sundays when it always ran to Clacton. William Marriott Museum Collection/Midland & Great Northern Joint Railway Society

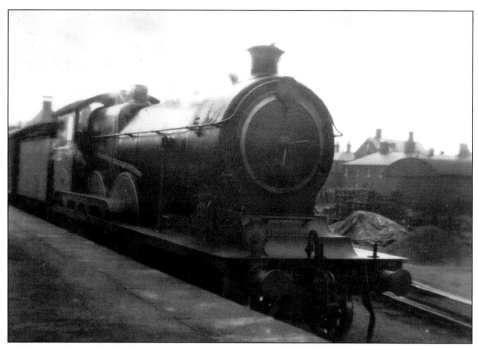

Taken against the light, B12 8562 (ex 1562 and later 7476 followed by 1562), awaits departure from Beccles Junction on an empty milk train in August 1927. This loco was rebuilt to B12/3 class in 1938. E. Cotton

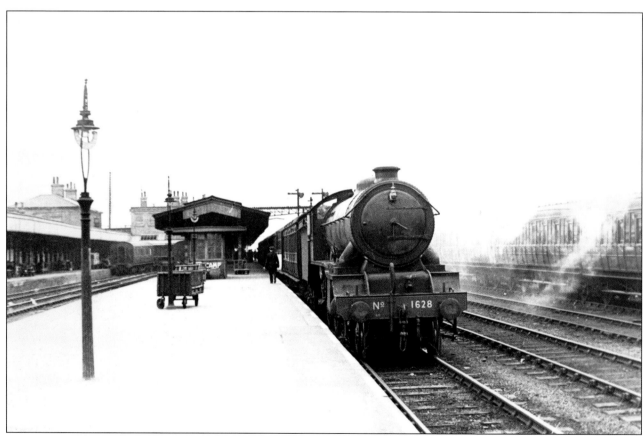

Cambridge shed's B17/2 class 1628 (ex 2828) HAREWOOD HOUSE awaits departure from its home station with a local Passenger train on 15 April 1947. Extensive carriage sidings are to the right of the loco.

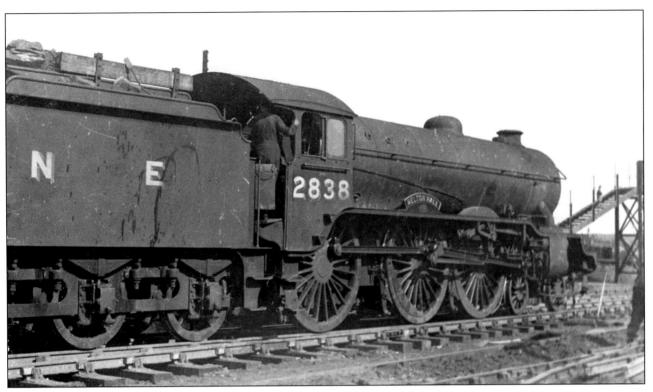

B17/2 class 2838 (later 1638) MELTON HALL waits to go off its home shed Cambridge on 7 April 1946.

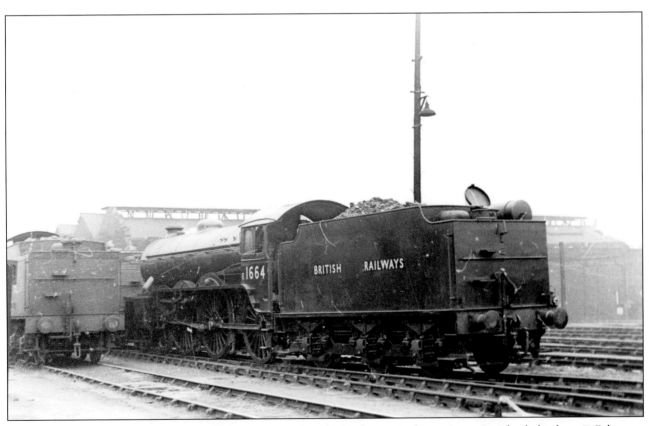

B17/6 class E1664 (ex 2864) LIVERPOOL from Colwick shed, Nottingham, is on Stratford shed on 7 February 1948. Its external condition suggests that it has recently emerged from Stratford Works. The inscription on the tender is in a small font.

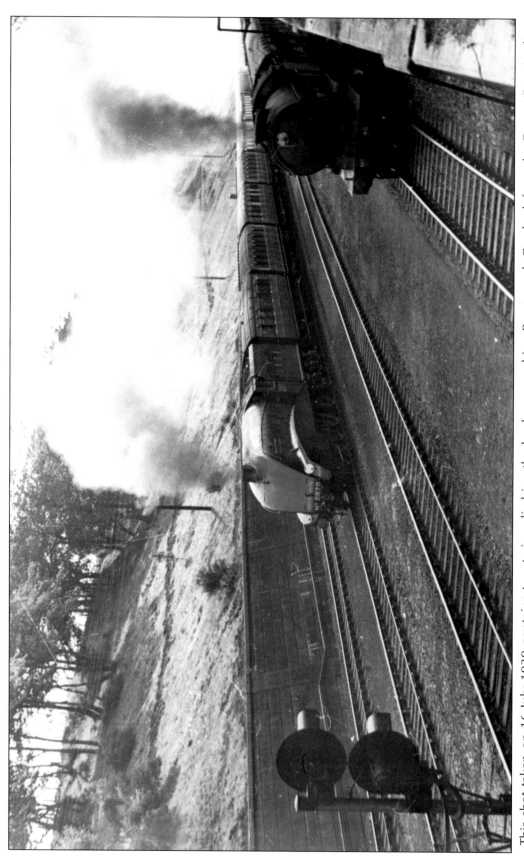

This shot taken on 16 July 1939 contains two trains climbing the bank approaching Brentwood. On the left on the Down 'East Anglian' express is B17/5 class 2870 (later 1670) CITY OF LONDON from Norwich shed. This loco which ran in its streamlined form from September 1937 until April 1951 had previously been named TOTTENHAM HOTSPUR and prior to that MANCHESTER CITY. On the right, working a Stopping Passenger train is B12/3 class 8540 (later 1540).

5

2-6-4 TANKS

These were mainly employed to work intermediate and local passenger trains but also worked parcels traffic.

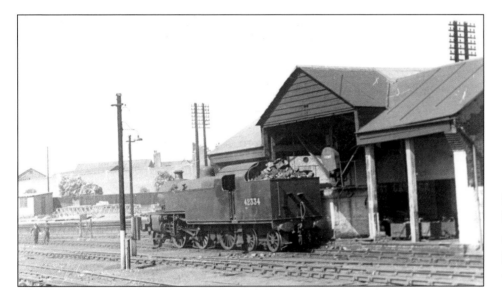

Fowler 4MT 42334 is at home alongside the distinctive Coal Stage at St Albans shed around 1949.

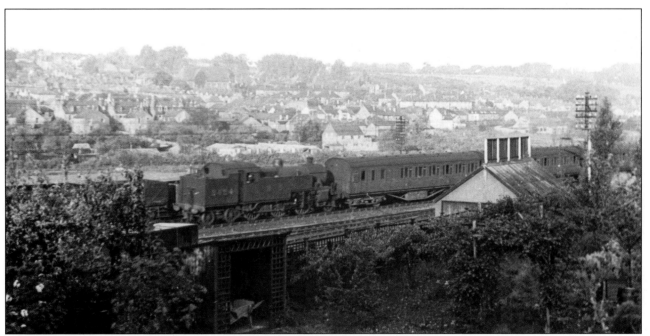

Willesden's Fowler 4MT 2424 sits on carriages in the yard at Berkhamsted around 1946.

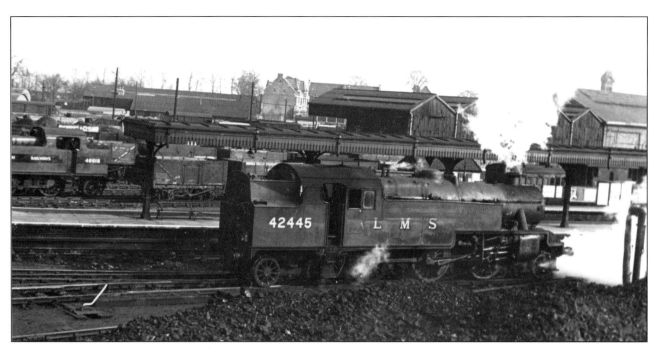

With its cylinder cocks open Watford's Stanier 4MT 42445 moves past Watford Junction station on 9 March 1949. Centre left in the yard, part of Willesden's Fowler 3MT 2-6-2T 40018 can be seen.

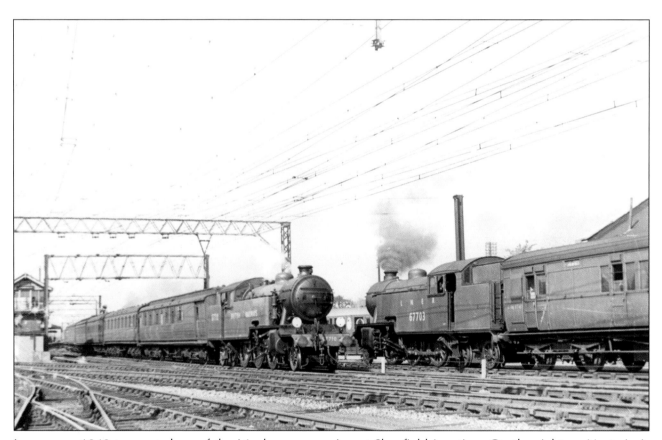

In summer 1948 two members of the L1 class are passing at Shenfield Junction. On the right an Up train is worked by 67703 (ex 9002) whilst on the left a Down train is headed by 67710 (ex E9009). Both locos were allocated to Stratford.

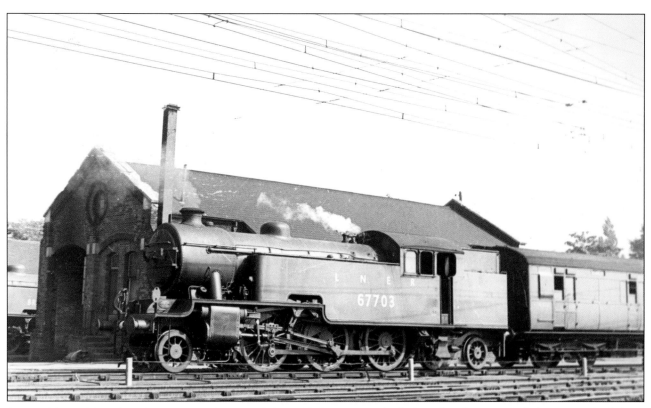

Around June 1948 L1 class 67703 (ex 9002) is at Rickmansworth during the short period that it worked from Neasden shed.

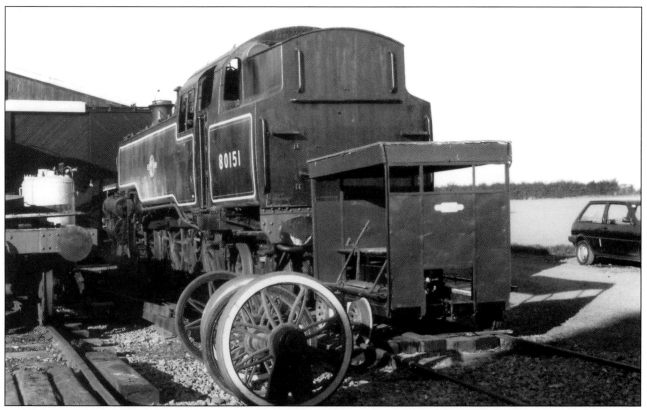

BR Standard 4MT 80151 is at the East Anglian Railway Museum at Chappel & Wakes Colne on 4 October 1986. This loco has moved to the Bluebell Railway. Maurice Dart

6
A 2-6-2 AND 2-6-0s

These were classed as Mixed Traffic locos so could be seen working a variety of trains.

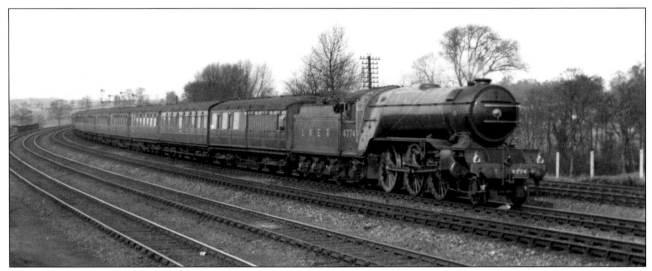

LNER V2 class 2-6-2 4774 (became 803) heads a Down express at Welwyn on 19 March 1938.

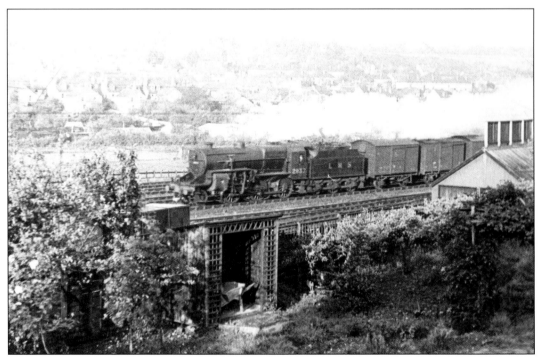

LMS 'Crab' 2-6-0 2837 passes Berkhamsted on a Down Goods around 1946. This loco was a long way from its home shed at Carlisle Kingmoor.

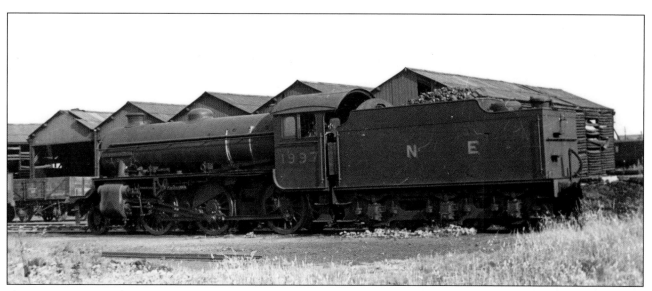

The prototype K1 class 2-6-0 1997 (originally 3445) MACCAILIN MOR on shed at Stratford on 4 June 1947 during the short period when it was allocated to Norwich shed.

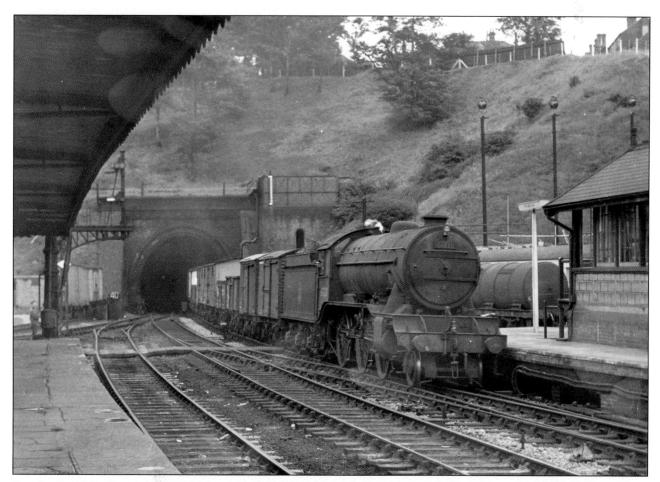

Stratford's K3/2 class 2-6-0 61820 (ex 58) enters Ipswich in the mid-1950s with a Down class B Goods'. The train is emerging from the east portal of the 361-yard Ipswich tunnel.

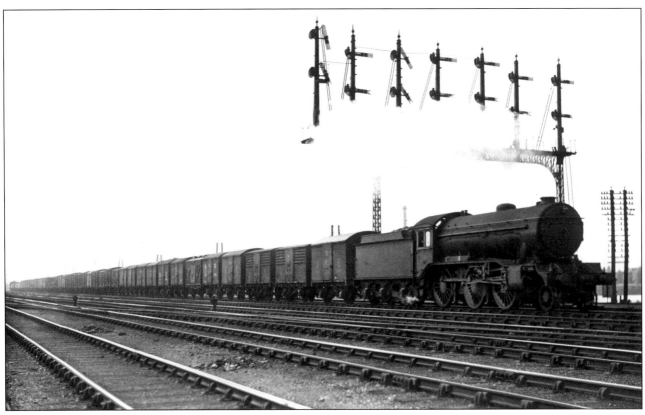

Doncaster's K3/2 class 2-6-0 1861 (previously 202) approaches Wood Green No. 1 Signal Box and has crossed from the Down Fast to the Down Slow line working a Down fish train in late 1946. Carl Stirk

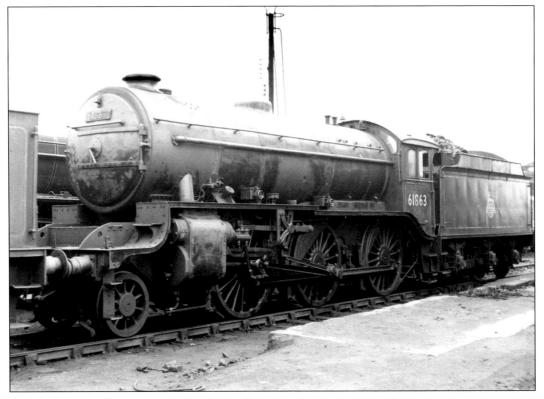

Stratford's K3/2 class 2-6-0 61863 (ex 206) rests at home in the mid-1950s.

7

0-6-2 TANKS

These types mainly worked local and branch passenger trains.

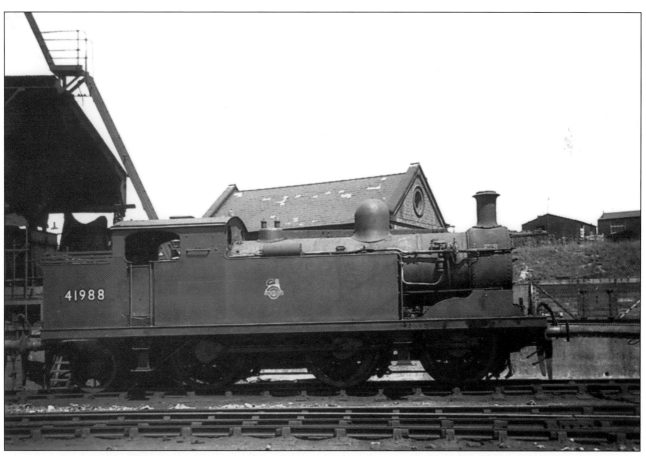

LTS class 69 41988 (previously 2188, 2228 and 2188) is at home by the Coaling plant at Plaistow shed in June 1957. Harry Cowan

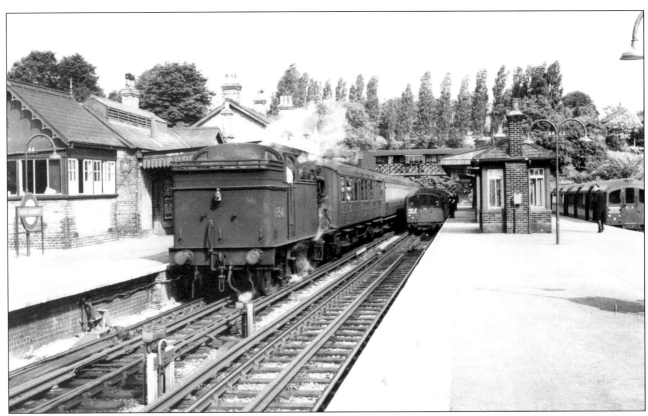

Around 1950 an enthusiasts special train is at High Barnet in charge of Kings Cross shed's N2/1 class 69540 (ex 4761). Two Northern line sets bound for Morden are at the Island platform. A. W. Burges

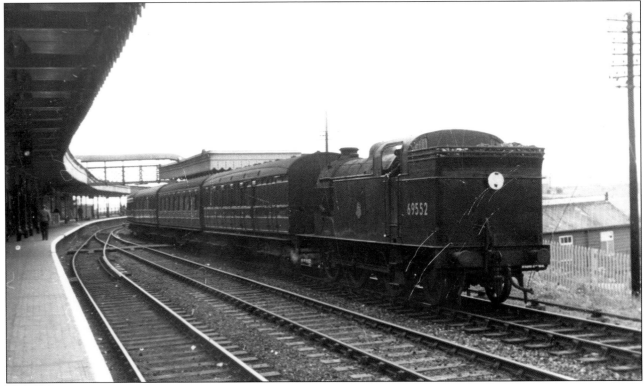

An Up branch train is stopped at Harwich Parkeston Quay on 14 May 1956 hauled by N2/2 class 69552 (previously 2585) which was based at Parkeston.

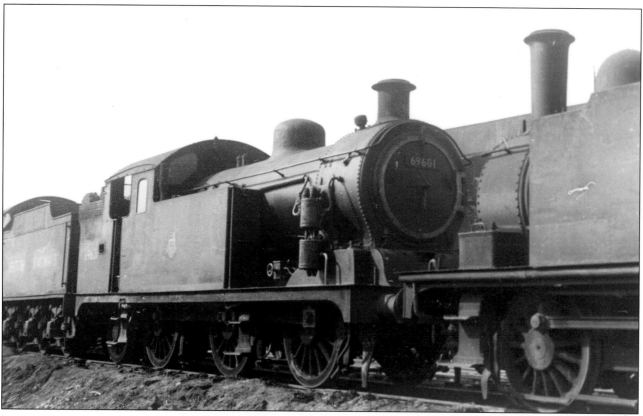

N7/4 class 69601 (ex 7979 and 8001) is at home at Stratford shed on 15 March 1953.

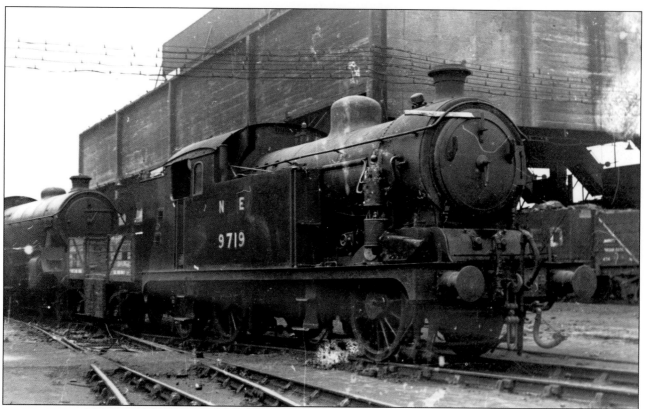

Resting at home near the massive coal stage at Stratford shed in 1947 is N7/3 class 9719 (ex 2617). Austerity lettering N E is on the tank sides. What is the purpose of the slat of wood wedged under the handrail?

8

0-6-0s

These worked local and branch passenger and goods trains.

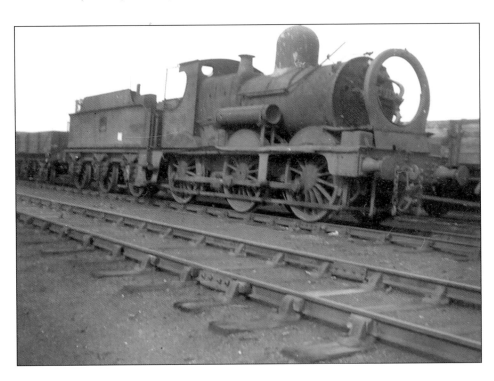

GWR Dean Goods 0-6-0 2461 at Cohen's yard, Canning Town in March 1949 after return from service in France with the War Department who numbered it 184 and 030-W040. This loco had also worked overseas for the WD in the First World War. Ernest Foster

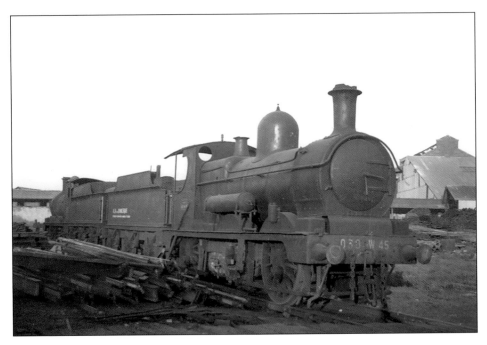

Cohen's yard at Canning Town in March 1949 contained several GWR Dean Goods 0-6-0s which had returned from service in France with the War Department. Nearest to the camera is 2561 (WD 110 and 030-W045) with 2547 (WD 115) in the background. Kenneth Brown

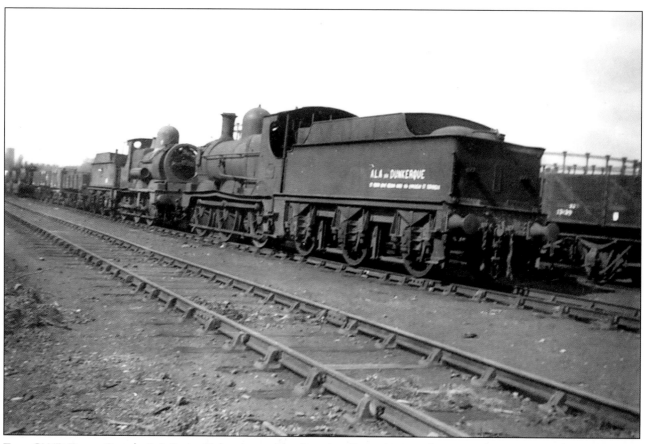

Two GWR Dean Goods 0-6-0s in Cohen's yard at Canning Town in March 1949 after return from working for the War Department in France. In the background is 2461 (WD 184 and 030-W040) whilst nearest to the camera is 2567 (WD 116 and 030-W037). Ernest Foster

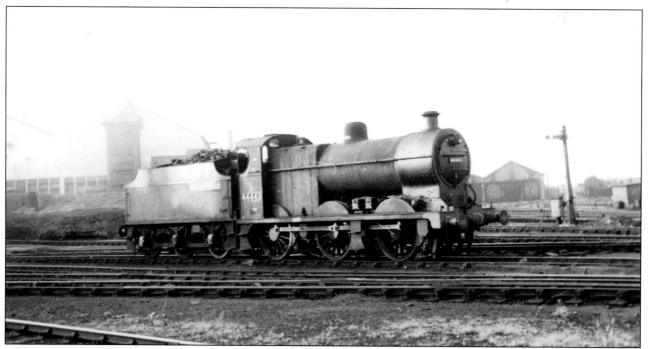

LMS 4F 0-6-0 44443 stands near its home shed at Watford on 29 July 1954. The carriage shed is in the right background.

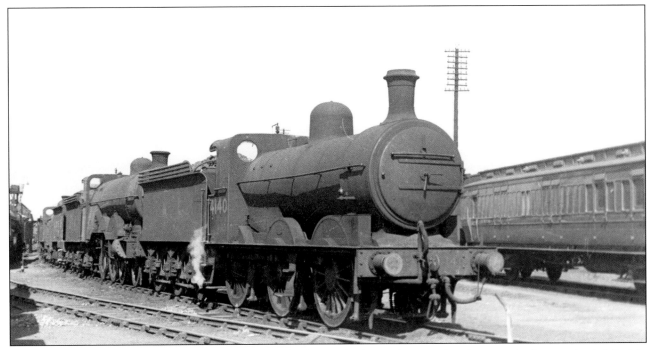

J3 class 4140 (ex 3306) loiters in light steam at the front of a line of interesting locos at its home shed, Hitchin on 7 April 1946.

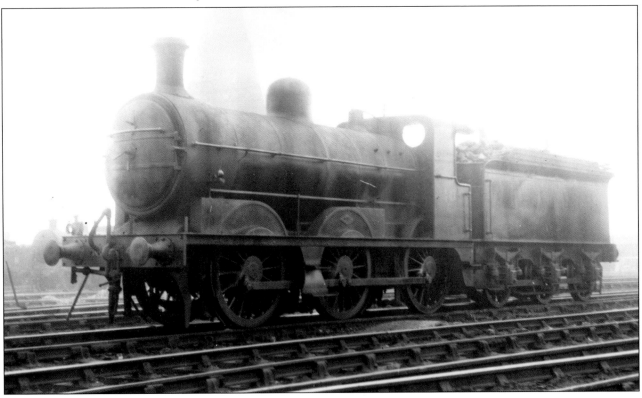

New England shed, Peterborough's J3 class 4106 (ex 4035) stands in the shed yard at Cambridge in mid-1947.

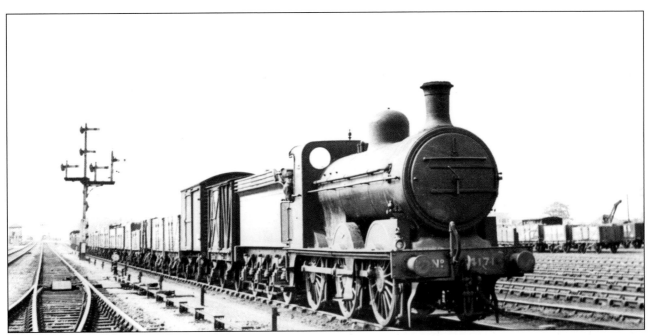

J4 class 4171 (later 4154) heads a lengthy Goods at South Lynn on 27 May 1937. This loco was withdrawn in November of that year.

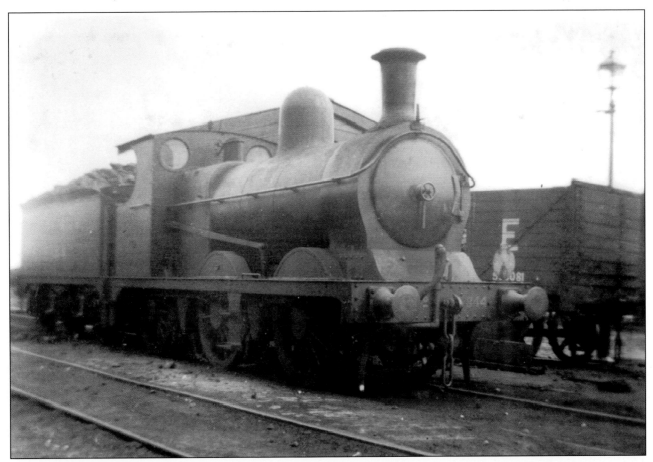

J10 class 5844 near the Coal Stage at home at Lowestoft Central shed during Easter, April 1927. This loco was converted to a J10/4 class and was withdrawn in February 1935. E. Cotton

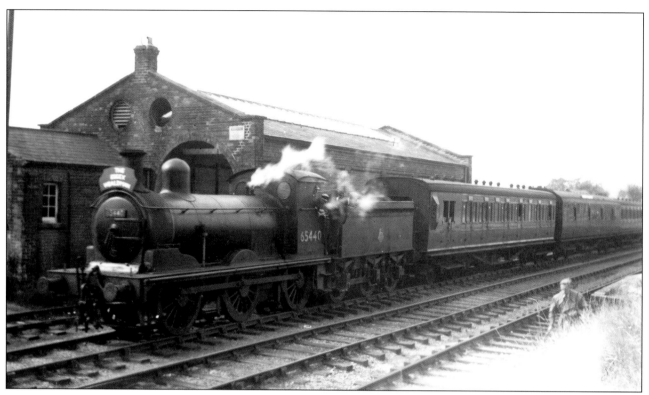

Stratford's J15 class 65440 (ex 7640) on the ESSEX WEALDMAN Railtour is stopped alongside the Goods shed at Ongar LTE on 28 September 1958. Ernest Foster

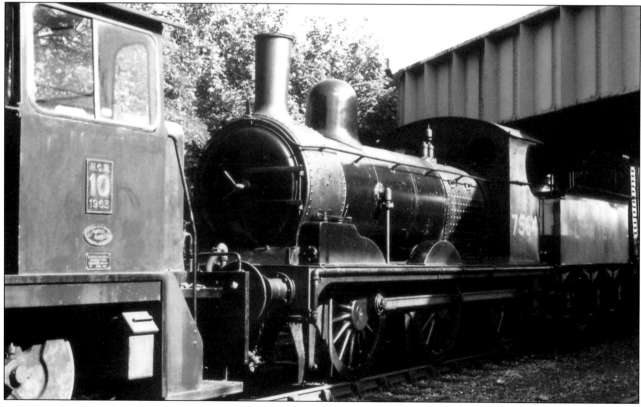

J15 class 7564 (became 5462) in the yard at Sheringham on the North Norfolk Railway on 3 October 1986. To its left is 0-4-0DH NCB 10 (EES 8431/1963) and to its rear is 350HP Diesel shunter 12131. Maurice Dart

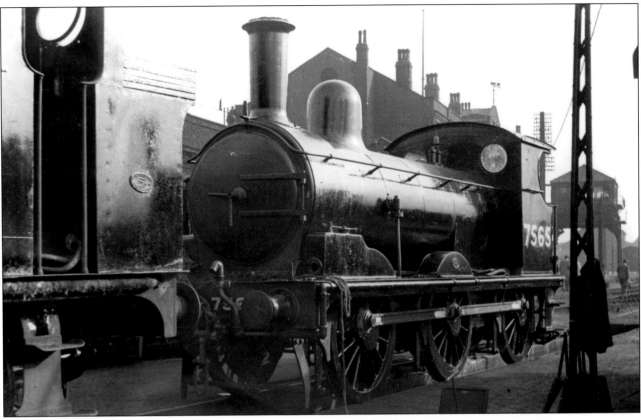

Ex-Works at Stratford shed devoid of its tender on 12 March 1938 is J15 class 7565 (later 5463).

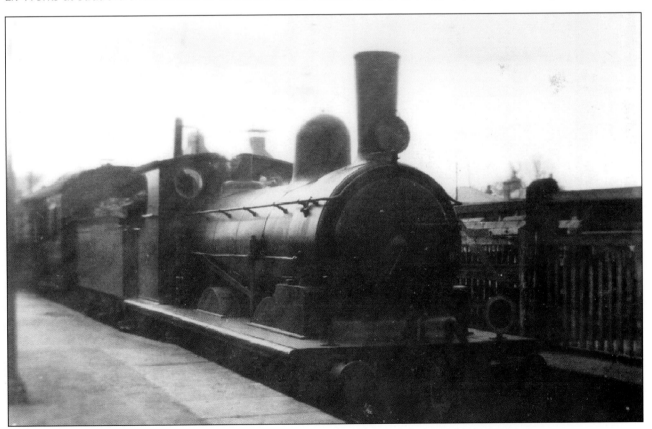

In August 1927 J15 class 7543 (became 5471) is at Beccles Junction on a Waveney Valley line train. E. Cotton

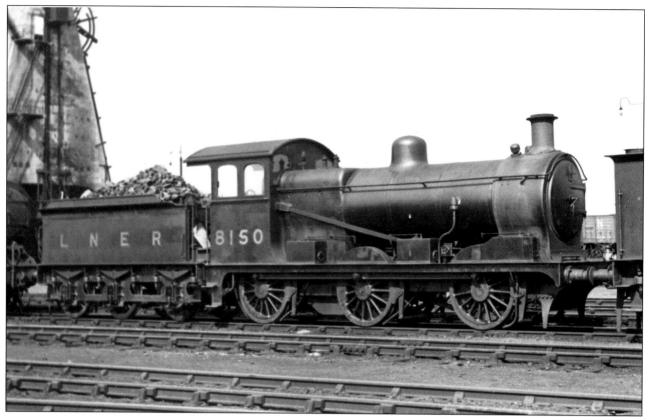

In the late 1930s J17 class 8150 (became 5500) is near the automatic coaling plant at March shed.

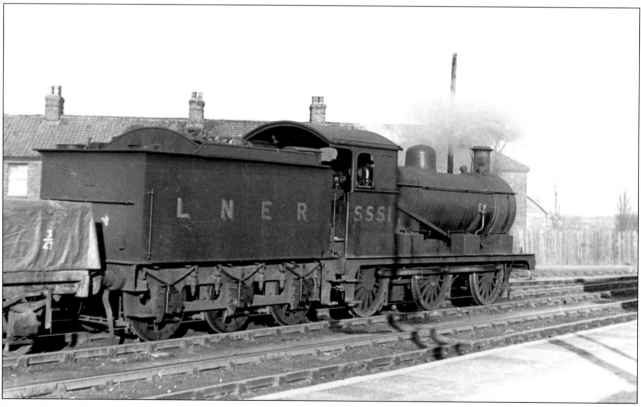

Norwich shed's J17 class 5551 (previously 8201) passes through Melton Constable on a Goods on 15 April 1947.

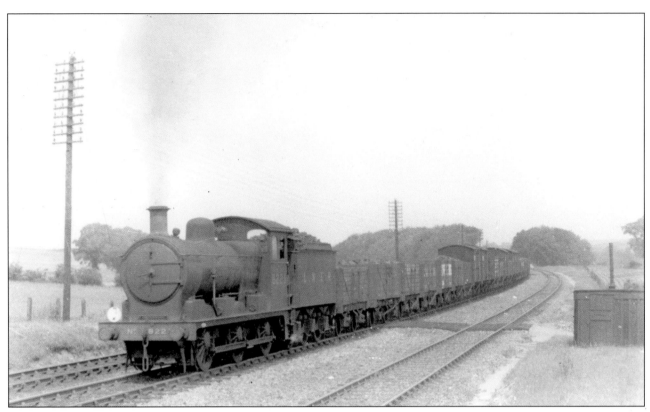

J17 class 8223 (became 5573) approaches Littlebury on a Mixed Goods on 27 June 1936.

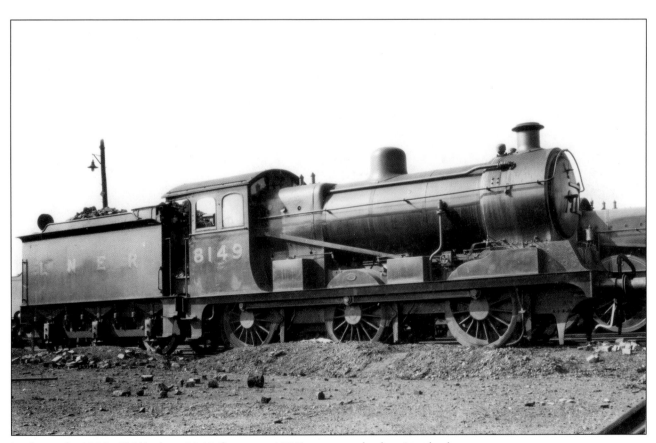

In the early 1930s J19/1 class 8149 (became 4659) rests on shed at Stratford.

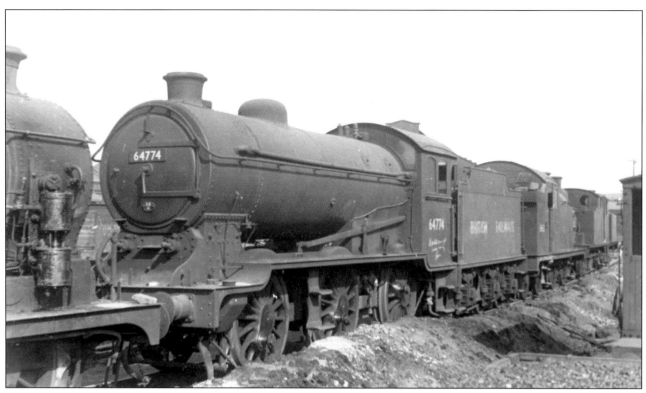

Stratford's J39 class 64774 (ex 2721) rests among piles of ash at its home shed on 15 March 1953.

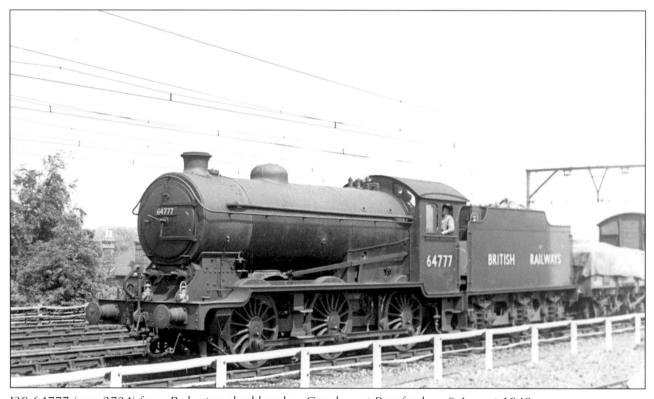

J39 64777 (was 2724) from Parkeston shed heads a Goods past Romford on 9 August 1949.

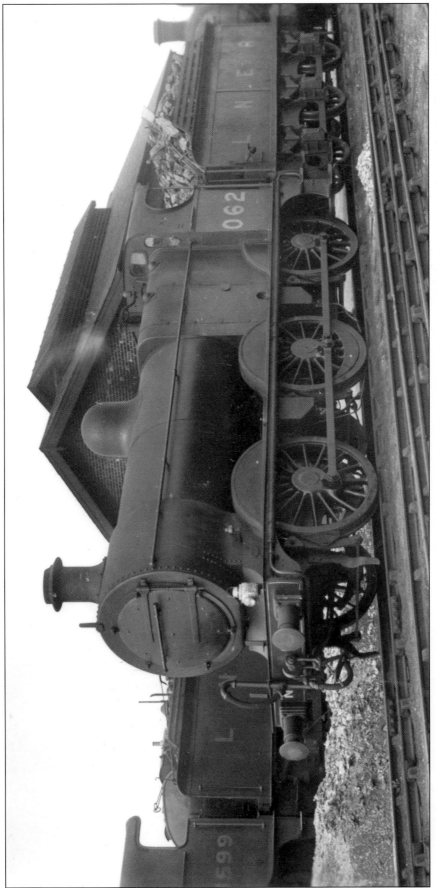

LNER J41 class (ex M&GNR) 062 is coaled ready for work at Melton Constable shed in May 1937. This loco was withdrawn during October 1939. In the left background is J6 class 0-6-0 3599 which became 4248. Real Photographs

9

0-6-0 TANKS

These worked mainly as shunting locos in yards and at stations but also worked some branch goods trains.

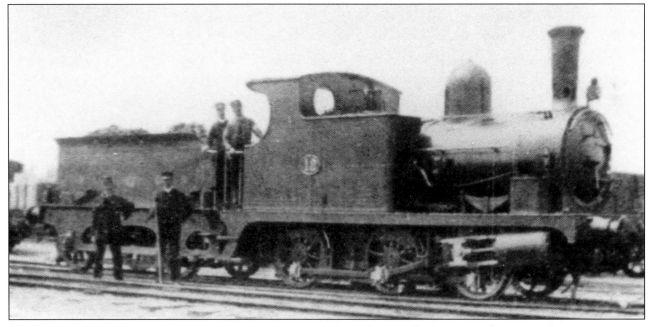

Surprisingly this section commences with photos of three locos which originally came from companies associated with the GWR. This loco started out as Cornwall Minerals Railway 0-6-0T No.12. It was sold in 1881 to the Lynn & Fakenham Railway which became part of the Eastern & Midlands Railway. In turn this became part of the Great Eastern Railway and then LNER. The L&F Railway fitted the locos with a tender to increase their range of working. Parts of the loco eventually became LNER J93 class having successively been numbered 12A, 97 and 097. It was withdrawn in March 1943. The photo which was taken in the early 1900s appears to be at South Lynn yards where the locos worked regularly.

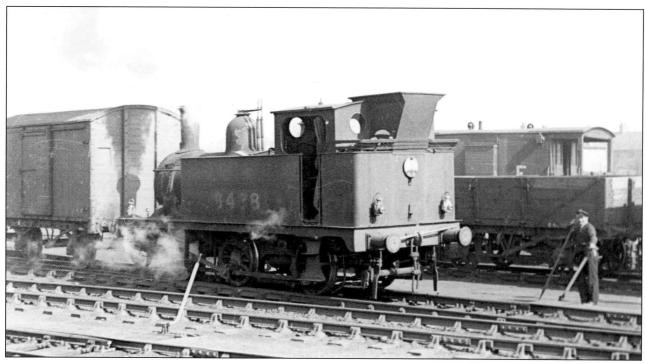

This is LNER J93 class 0-6-0T 8488 shunting at South Lynn on 16 April 1947. Parts of this loco started life as Cornwall Minerals Railway No.16. Around 1880 it was sold back to Sharp Stewart & Co. who sold it to the Lynn & Fakenham Railway where it became 2A and was named REEPHAM. It progressed to the Eastern & Midlands Railway followed by the GER and the LNER being successively numbered 2A, 94, 094 and 8488. Withdrawal took place in January 1948.

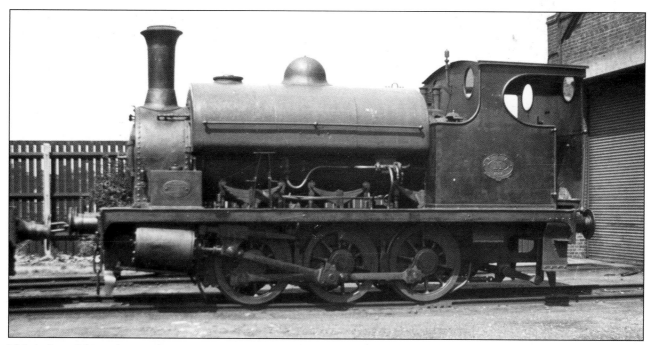

This is Port Of London Authority 0-6-0ST No.11 at Custom House in the 1930s. This loco (RS 3050/1901) started life as LOOE on the LIskeard & Caradon Railway. Having been purchased in April 1901 it proved to be unsuitable for the line and was sold in April 1902 to the London & India Docks. Scrapping took place in December 1950. Locomotive & General Railway Photographs

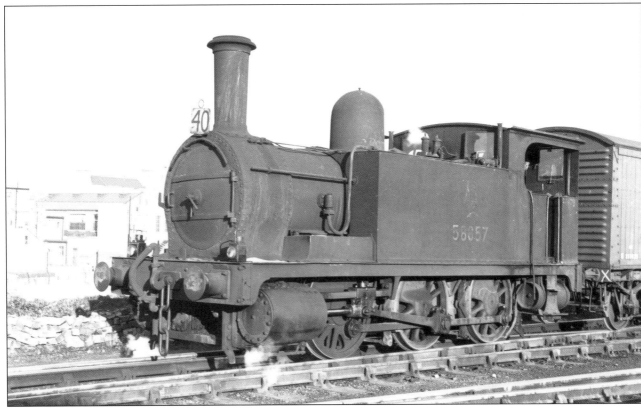

North London Railway 0-6-0T 58857 from Devons Road shed shunts at Poplar in February 1957. The loco is coupled to LNER 12T van E237825. P. H. Groom

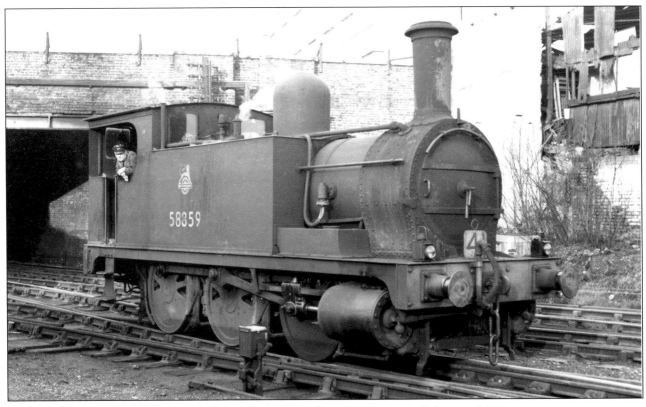

Devons Road's North London Railway 0-6-0T 58859 shunts at Poplar in February 1957. P. H. Groom

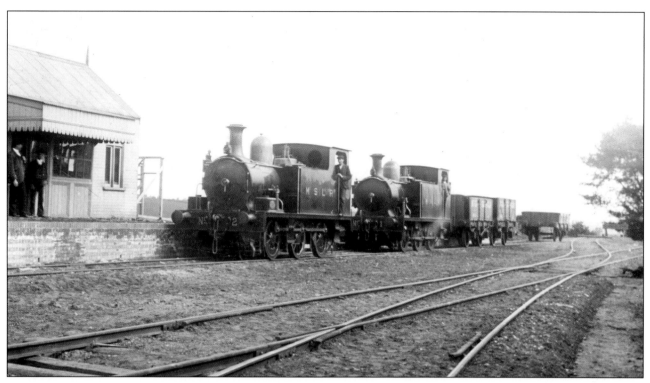

Two of the three Mid-Suffolk Light Railway 0-6-0Ts which became LNER J64 class at Laxfield in the early 1920s. The line was absorbed into the LNER on 1 July 1924. Nearest to the camera is No.2 which became LNER 8317 and was withdrawn in December 1929. To its rear is No.1 which became LNER 8316 with withdrawal taking place in January 1928. Locomotive Publishing Co.

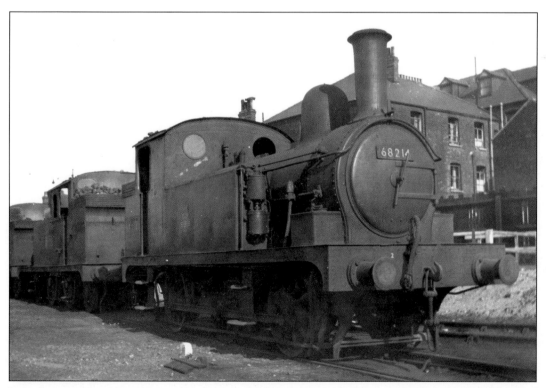

J65 class 68214 (ex 7250) at its home shed, Yarmouth Beach in October 1951. This shed closed on 2 March 1959.

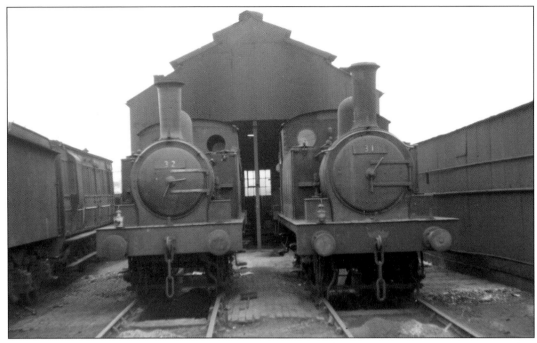

A pair of J66 class locos after their transfer to Service Stock outside the small shed used to house the works' shunters at Stratford Works on 26 October 1958. On the left is 32 (ex 8370 and 7281) with 31 (ex 8382 and 7313) on the right. Transport Treasury

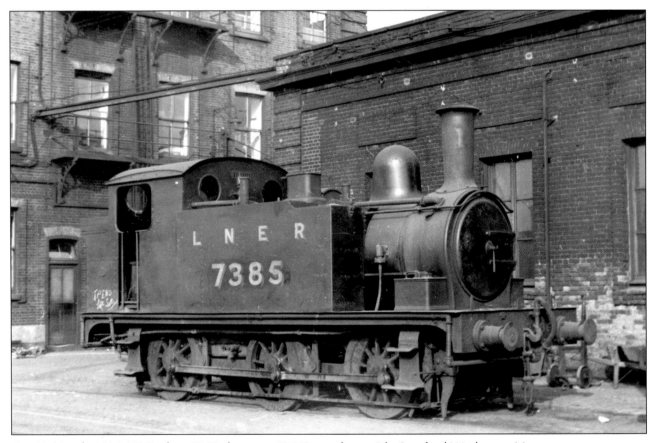

On 12 March 1938 J69/1 class 7385 (became 8561) stands outside Stratford Works awaiting entry.

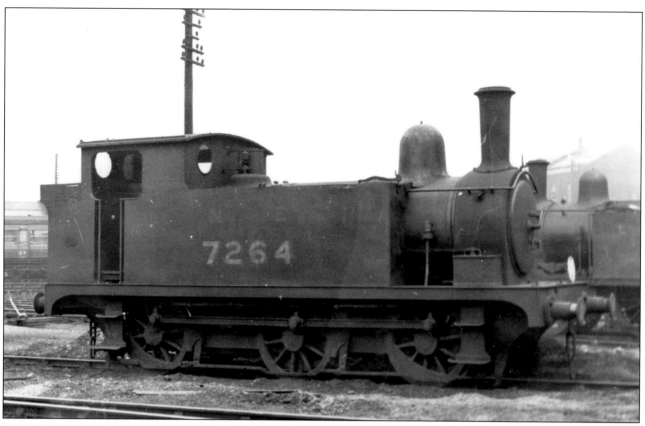

J67/1 class 7264 (became 8590) stands in the yard at Stratford shed on 26 March 1938.

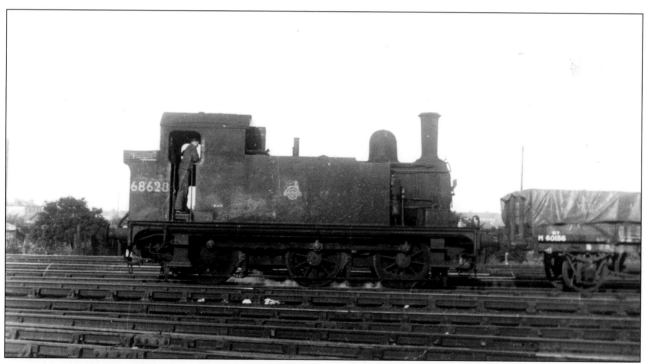

On 31 August 1951 J67/2 class 68628 (ex 7082) shunts in the yard at Yarmouth South Town where it was shedded. It is coupled to 5-plank Open wagon M60136. Goods traffic here ceased on 6 November 1967 with the passenger service following on 4 May 1970. The loco shed closed on 2 November 1969.

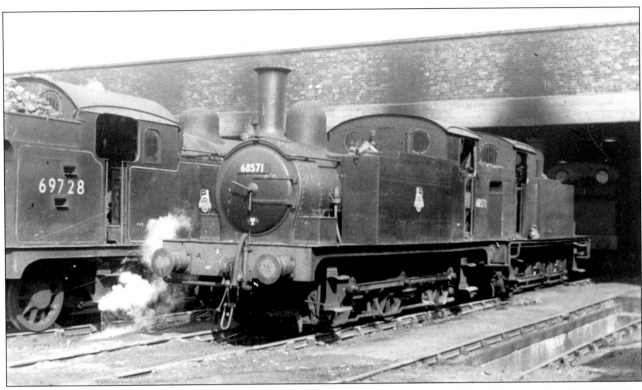

Two local engines are at home at Stratford on 15 March 1953. Partly concealed is N7/3 class 0-6-2T 69728 (ex 2626). The main feature of the photo is J69/1 class 68571 (ex 7395).

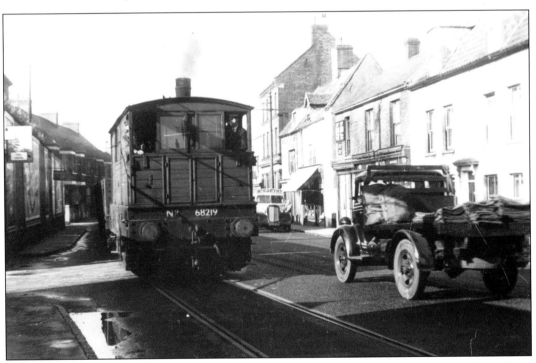

This photo presented me with a problem as the location quoted on its reverse stated it to have been taken at Norwich. However I am not aware of any line which traversed the streets of Norwich. Taken on 31 August 1951 J70 class 68219 (ex 7139) which was allocated to Yarmouth Vauxhall heads a Goods which I am assuming is passing through the town on the line to Yarmouth Fish Quay. This line closed on 1 January 1976.

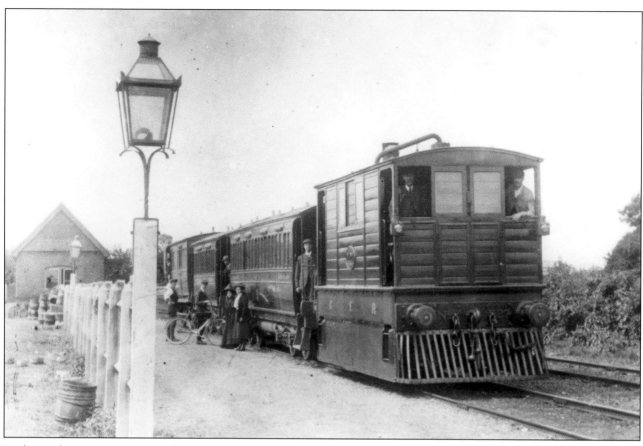

In the early 1920s GER 127 (became LNER J70 class 7127 and later 8221) heads a Passenger train at Outwell Village on the Wisbech & Upwell Tramway.

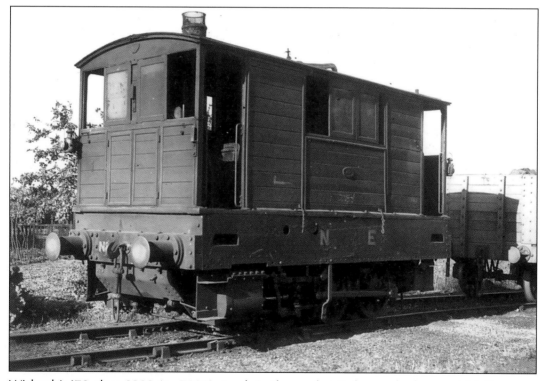

Wisbech's J70 class 8222 (ex 7128) stands in the yard at its home shed around 1947.

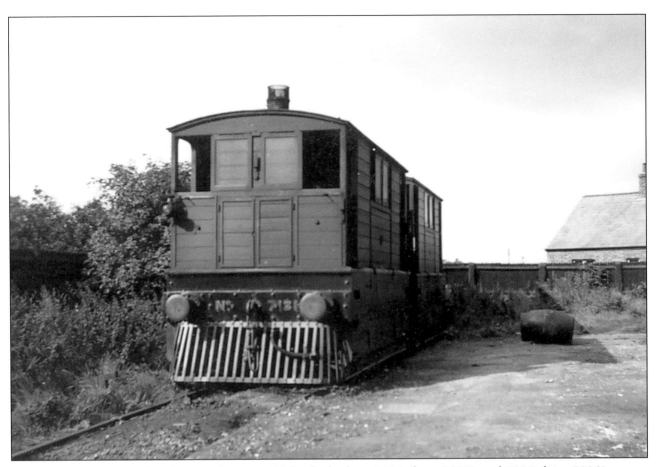

Around 1945 two J70 class locos at home at Wisbech shed are 7131 (later 8223) and 7130 (later 8220).

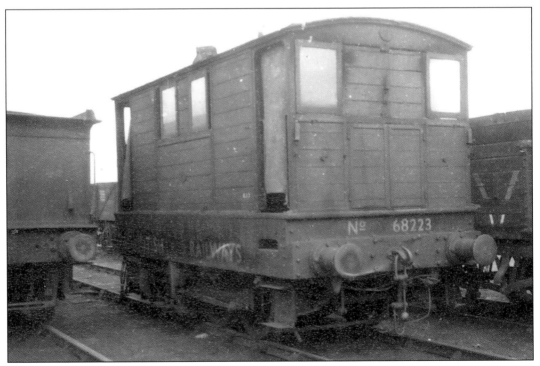

During its period allocated to March, J70 class 68223 (was 7131) rests at home in the shed yard on 31 May 1953. Kenneth Brown

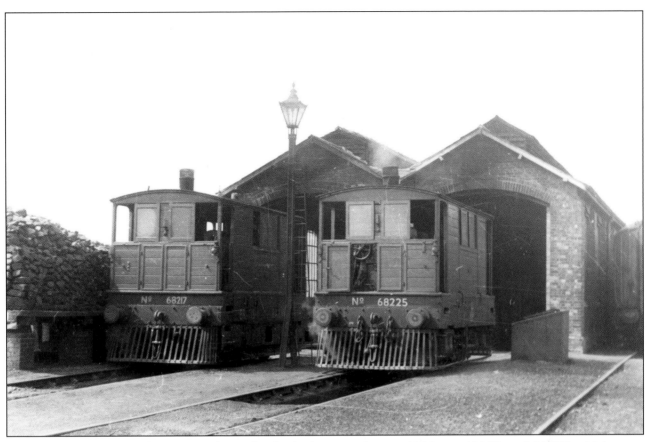

Two J70 class locos at home outside Wisbech shed on 20 August 1950 are 68217 and 68225 which were originally numbered 7136 and 7126.

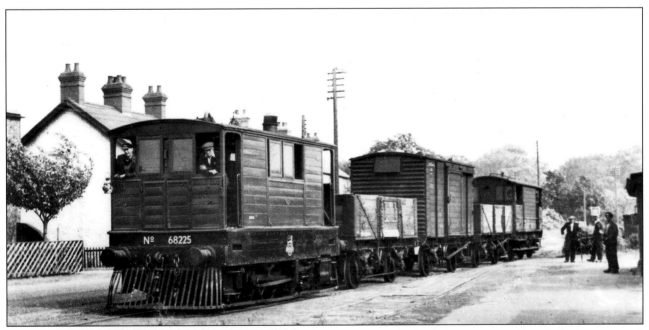

Wisbech's J70 class 68225 (ex 7126) passes Outwell Village with a short Goods train on the Wisbech & Upwell Tramway in the mid-1950s.

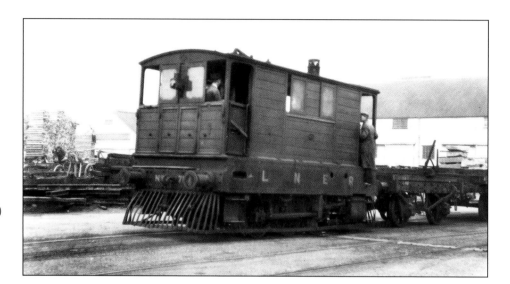

Lowestoft allocated J70 class 7139 (became 8219) shunts in the Timber yard at its home town in the late 1930s.

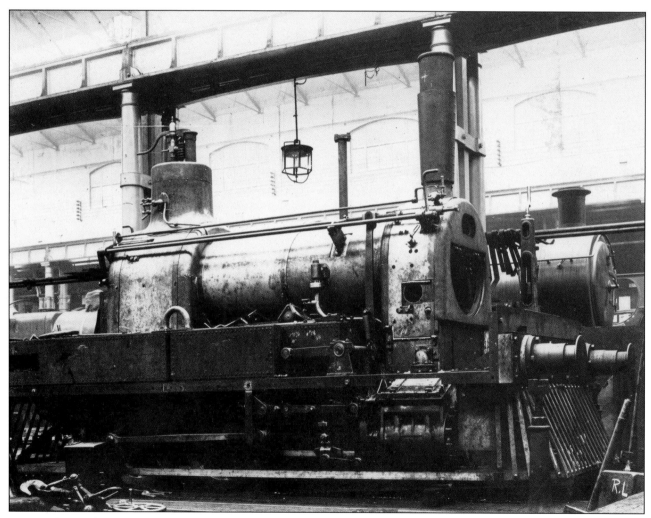

A rare photo of an unidentified J70 class Tram loco stripped of its external van type body undergoing overhaul in Stratford Works in the 1930s.

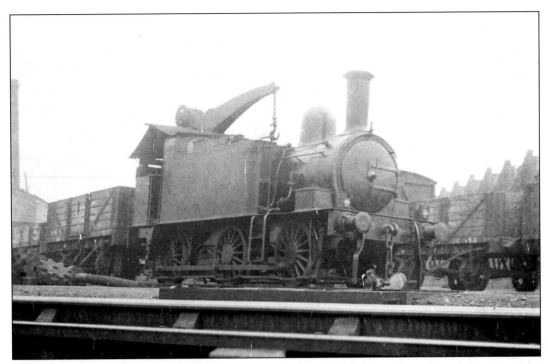

Service Loco J92 class 0-6-0 Crane tank 'B' (which became 8667) in the yard at Stratford Works in 1934. R. K. Curie

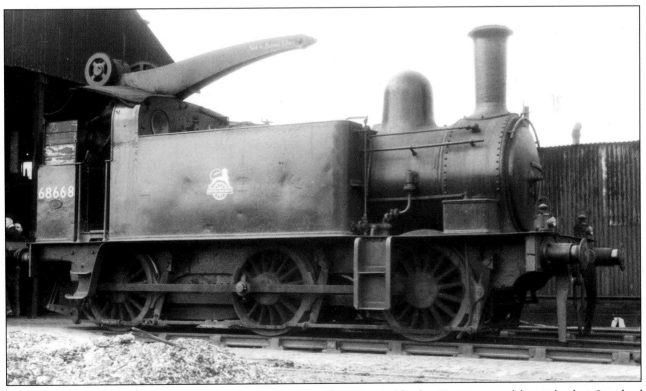

Service loco J92 class 0-6-0 Crane tank 68668 (originally 'C') outside the Departmental loco shed at Stratford on 30 April 1950. I saw both of these locos when I visited Stratford shed and Works in August 1950. B. K. B. Green/Initial Photographics

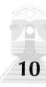

10

A 4-4-4T, A 4-4-2 AND 4-4-2 TANKS

The Atlantic tender locos worked expresses in their earlier years but later were relegated to less demanding duties. The tank locos mainly worked local and branch passenger services. This section includes a batch of ex London, Tilbury & Southend Railway 4-4-2Ts most of which have carried at least four numbers and were named in their early days. I have attempted to provide details of the numbers individual locos carried through their lives but have not quoted dates when changes occurred.

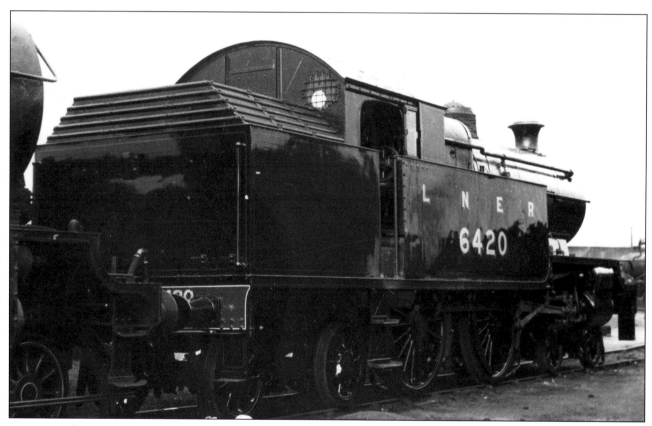

LNER H2 class 4-4-4T 6420 on shed at Stratford on 16 March 1938 in ex-Works condition. This loco which had originally been Metropolitan Railway H class, ex LPTB 108 was withdrawn in January 1946. These locos were taken over by the LNER on 1 November 1937 and were allocated to Neasden shed from where they worked services to Rickmansworth.

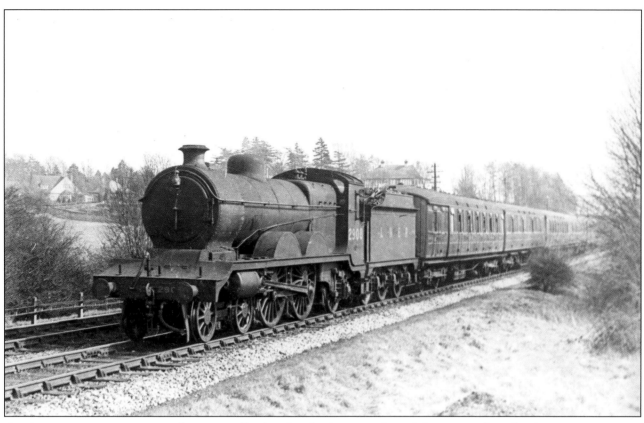

C4 class 4-4-2 2908 (ex 6084) from Woodford Halse shed approaches Rickmansworth with a Stopping Passenger service on 7 April 1947. Withdrawal took place in November 1950.

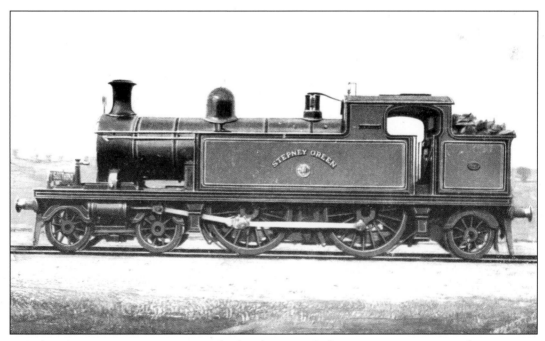

LTS class '2' 53 STEPNEY GREEN which subsequently became 2160, 2094 and LMS 1912. Withdrawal took place in 1949. The photo appears to be a record shot taken at Bow Works in the 1900s. Ian Allan Production

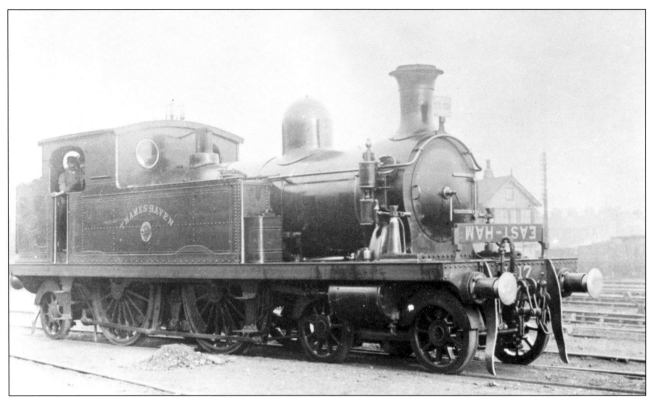

LTS class '1' 17 THAMES HAVEN at Plaistow shed around 1910. Other numbers carried were 33, 2117, 2084 and 1935. The loco was withdrawn before 1934.

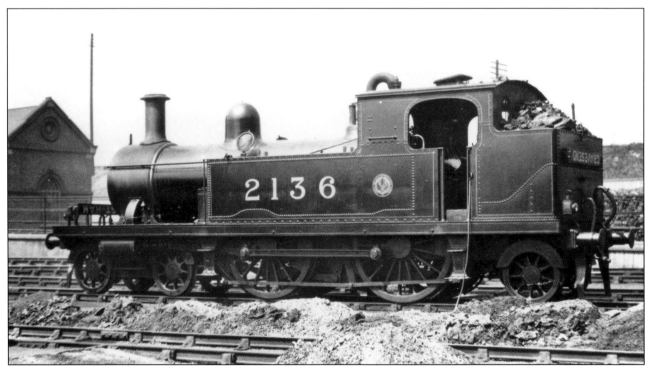

LTS 1P 2136 on shed at Plaistow on 12 July 1924. Later renumbered 2057 it had previously been numbered 2 and named GRAVESEND. Withdrawal occurred before 1934. Pamlin Prints

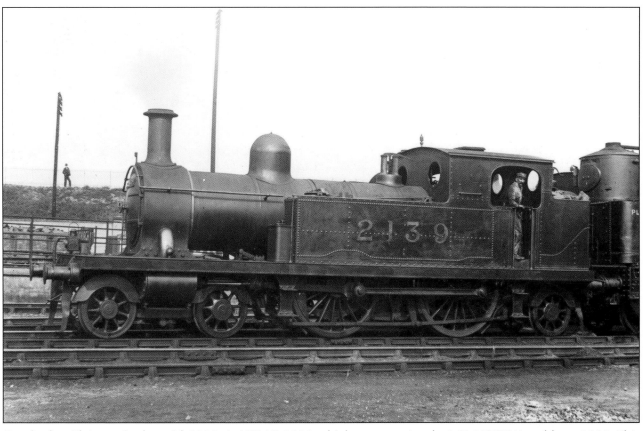

On shed at Plaistow in the mid-1920s is LTS 1P 2139 which was previously 5 PLAISTOW and later 2060. This loco was withdrawn in 1934.

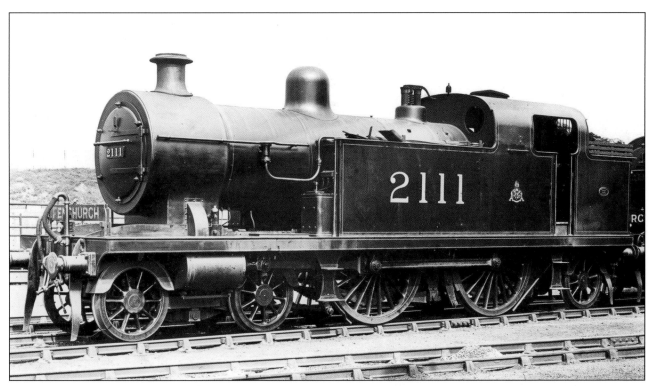

On shed at Plaistow in the mid-1920s is LTS 1P 2111 which had started life as 21 UPMINSTER and became 2078. This loco worked until 1935.

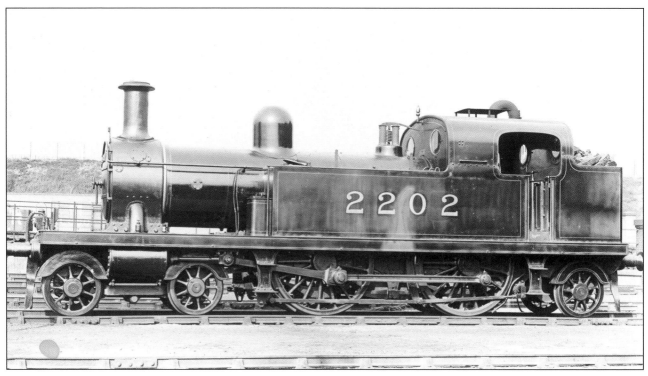

LTS 1P 2202 is on Plaistow shed in the late 1920s. Originally numbered 22 followed by 2112 it had been named EAST HORNDON which was changed to COMMERCIAL ROAD. It was subsequently renumbered to 2079 and was withdrawn in 1935.

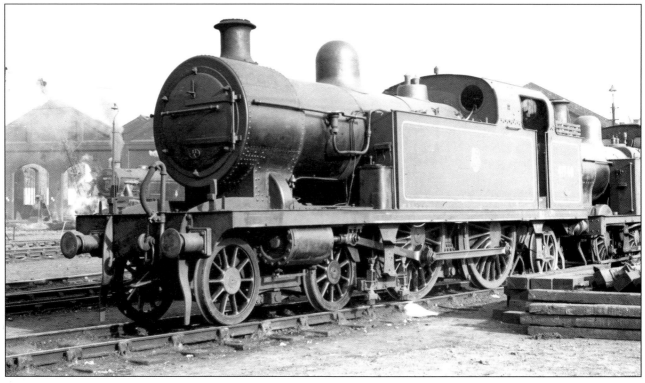

In March 1958 LTS 3P 41948 is at home on shed at Plaistow. The loco has been fitted with brushes to de-ice electrified lines. Earlier numbers carried were 2130, 2171 and 32 and it had been named LEYTON. In the left background is 4P 2-6-4T 42500 from Shoeburyness shed. P. H. Groom

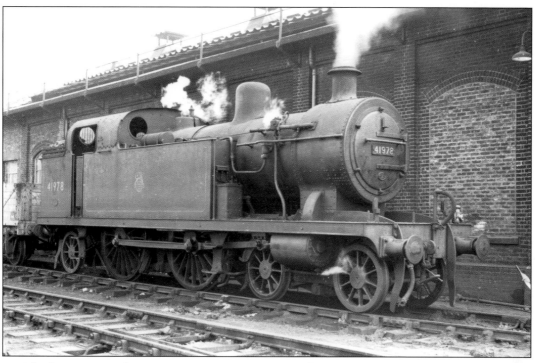

LMS built to an LTS design 3P 41978 (ex 2154) is at home at Plaistow shed in March 1958.
P. H. Groom

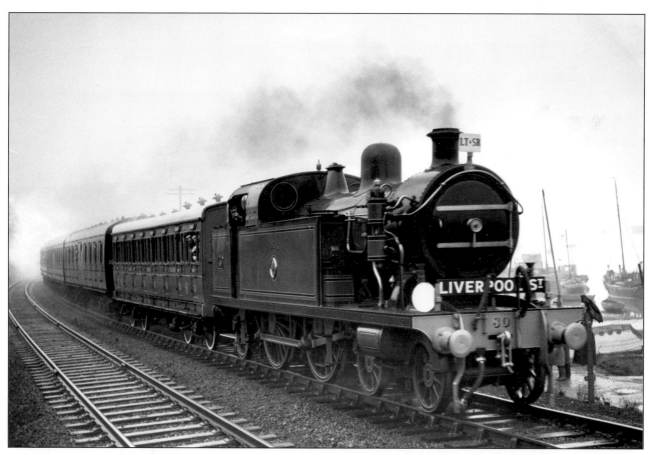

Preserved LTS 80 THUNDERSLEY (became 66, 2177, 2148 and BR 41966) is working an Up special train between Southend East and Thorpe Bay, early in 1962. The Times

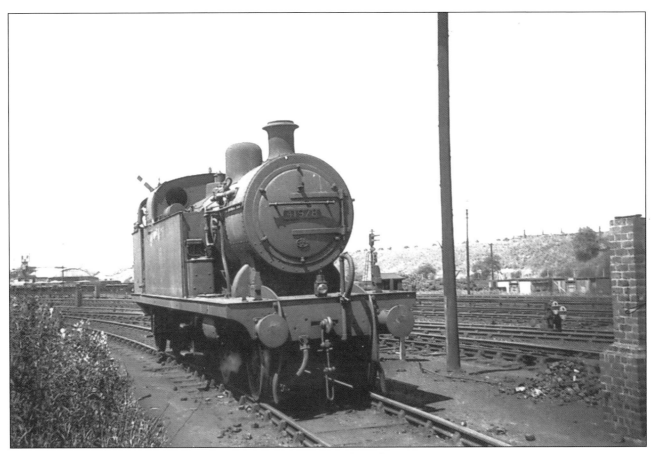

LMS built LTS class 79 4-4-2T 41978 goes off its home shed at Plaistow in June 1957. Harry Cowan

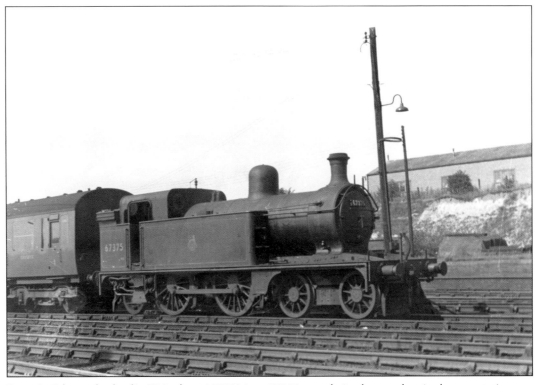

Bury St Edmunds shed's C12 class 67375 (ex 4520) stands in the yard at its home station on 19 September 1953. The loco is coupled to Thompson carriage E88505E.

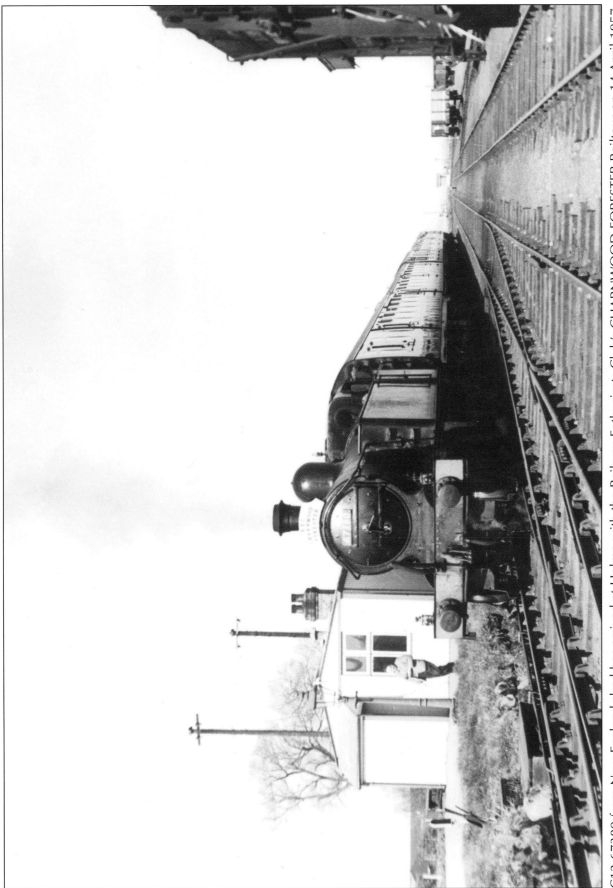

C12 67380 from New England shed has arrived at Holme with the Railway Enthusiasts Club's CHARNWOOD FORESTER Railtour on 14 April 1957. This station lost its passenger service on 6 April 1959 and closed to goods traffic on 31 October 1970.

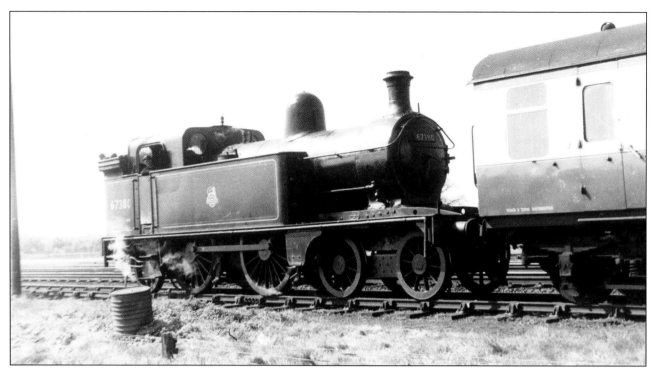

On 14 April 1957 New England's C12 class 67380 has run around the special train and waits to depart from Holme.

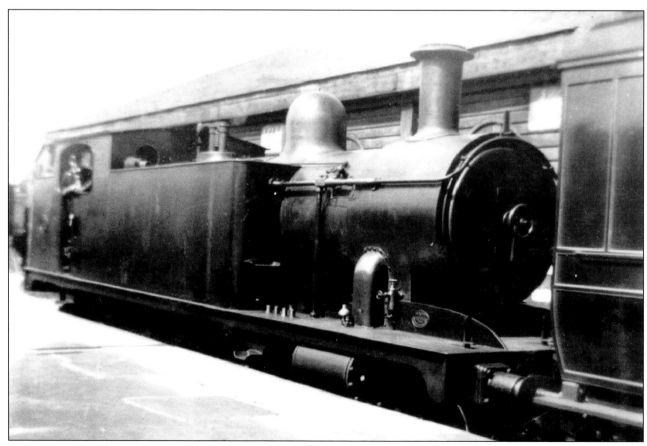

Ex Midland & Great Northern Railway, LNER C17 class, 020 waits to depart from Lowestoft Central with a train to Yarmouth Beach in August 1927. Withdrawal took place in April 1944. E. Cotton

11

4-4-0s

These types worked on all types of passenger trains on the area.

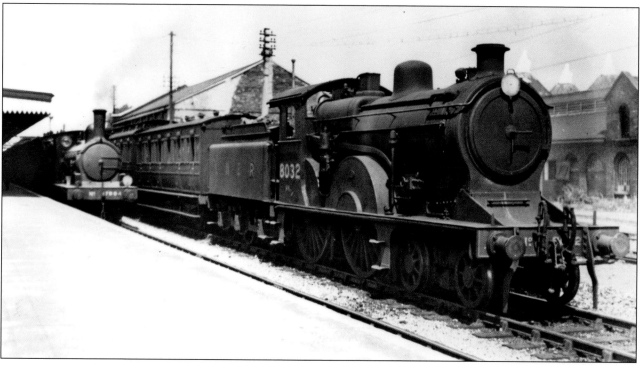

Two trains stand in the station at Dereham on 8 July 1936. On the left is J15 class 0-6-0 7904 (later 5400) which was withdrawn in February 1948. The main subject is Norwich shed's D13 class 4-4-0 8032 which was withdrawn two months later. This loco had been rebuilt from a T19 class 2-4-0. Maltings are in the right background. This station, on the line from Wymondham to Wells, closed to all traffic on 6 October 1969.
Pamlin Prints

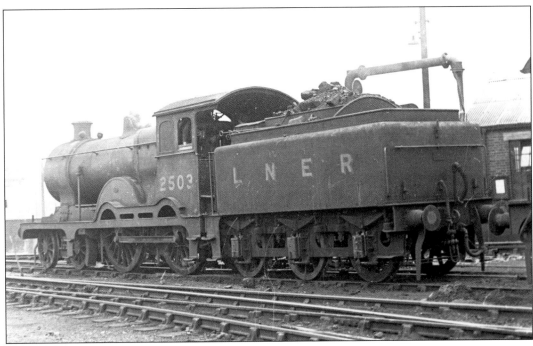

On shed at Cambridge on 15 April 1947 is Bury St Edmunds shed's D15/2 class 2503 (ex 8892). The loco is fitted with a 'Bohemian' or 'Watercart' tender which once held a tank for an oil-burning loco.

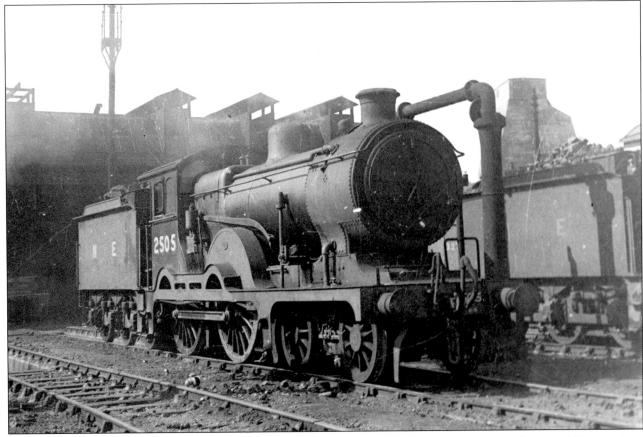

Kings Lynn's D15/2 class 2505 (ex 8894) simmers in front of Cambridge shed on 7 April 1946. Wartime N E lettering is on the tender. The Coaling Plant is in the right background.

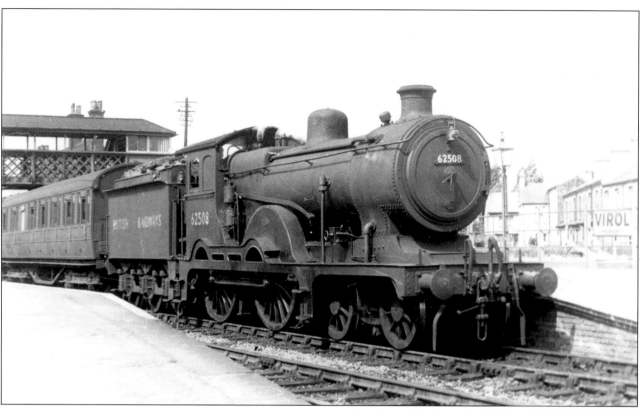

On 20 August 1950 Bury St Edmunds shed's D15/2 class 62508 (ex 8897) awaits departure from Wisbech East on a local passenger train. This loco was withdrawn on 25 November of that year. Passenger services ceased on 5 September 1968 but freight lingered on until 29 February 2004.

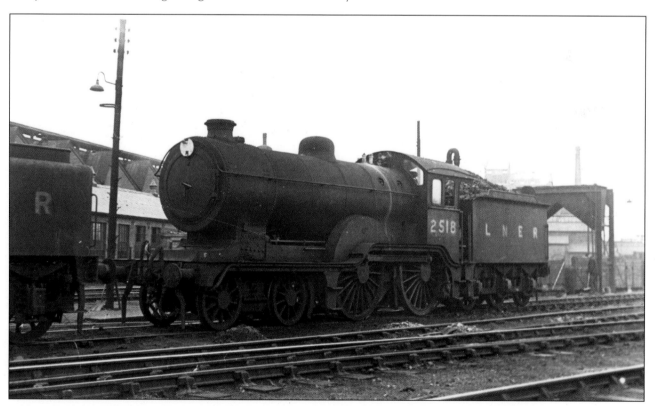

In the yard at Cambridge shed on 15 April 1947 is King Lynn's D16/3 class 2518 (ex 8887).

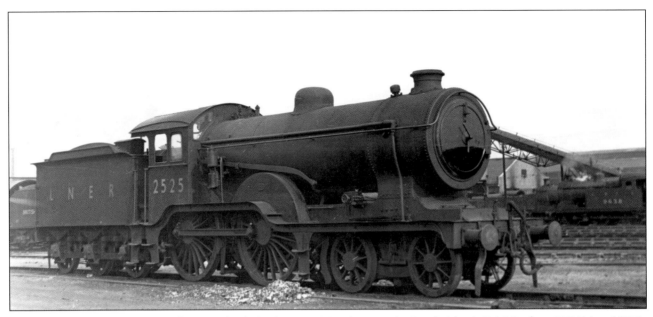

Standing in the extensive yard at Stratford shed on 26 March 1949 is Cambridge's D16/3 class 2525 (ex 8874). In the right background, at home is N7/5 class 0-6-2T 9638 (ex 833).

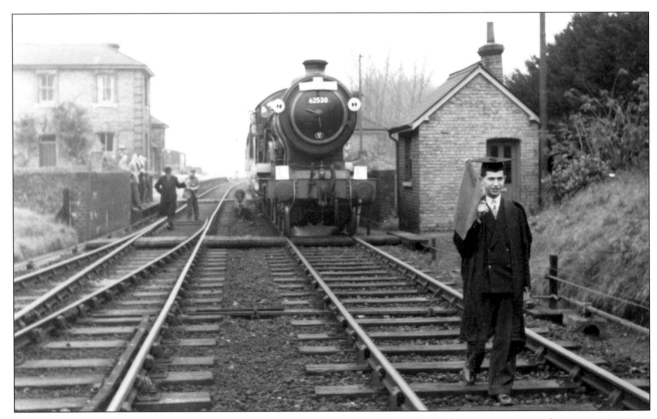

Cambridge shed's D16/3 class 62530 (ex 8879), carrying a headboard which appears to read 'BR FAREWELL', stands at County School, the junction for lines to Wells and Wroxham at an unknown date but most certainly on a special working in 1956/57. One of the masters from the school is walking along the track carrying a guard's flag prominently. A Locomotive Inspector is walking along the Up line motioning with his hand to the driver to gradually inch forward off the train. Goods traffic ceased on 13 July 1964 with the passenger service following on 5 October the same year.

D16/3 class 2561 (ex 8830) from Yarmouth Beach shed awaits departure from Melton Constable on 15 April 1947. Passenger services ended on 6 October 1964 and shortly after on 28 December for freight.

Norwich's D16/3 class 2585 (ex 8814) stands in a line of locos at Stratford shed on 4 June 1947.

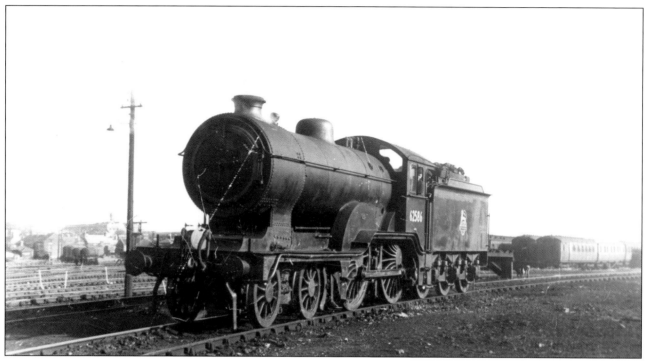

Norwich's D16/3 class 2586 (ex 8815) moves around the extensive carriage sidings at Thorpe on 31 August 1951.

A somewhat murky photo of D16/2 class 8800 (became 2591) waiting at Beccles Junction on a train to Liverpool Street in August 1927. Withdrawal took place in April 1950. E. Cotton

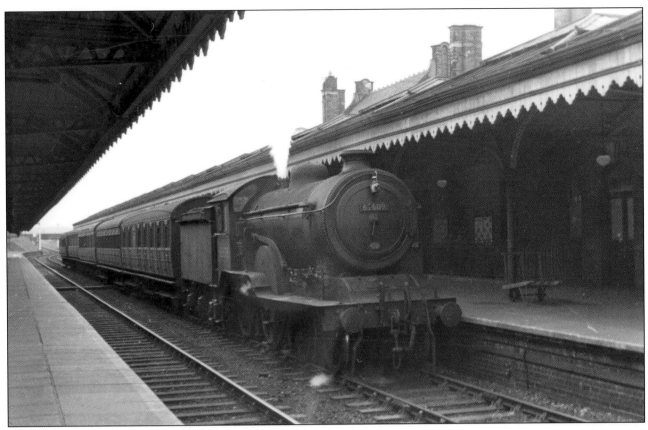

D16/3 class 62609 (ex 8798) from Spital shed, Peterborough stands at Newmarket on a Local working on 19 March 1953.

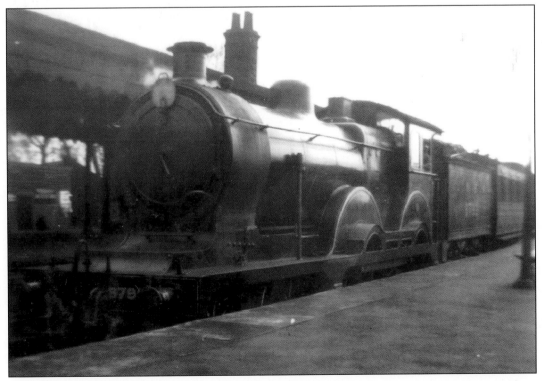

D15 class 8799 (later D16/3 class 2610) stands at Beccles Junction on a train to Yarmouth in August 1927. E. Cotton

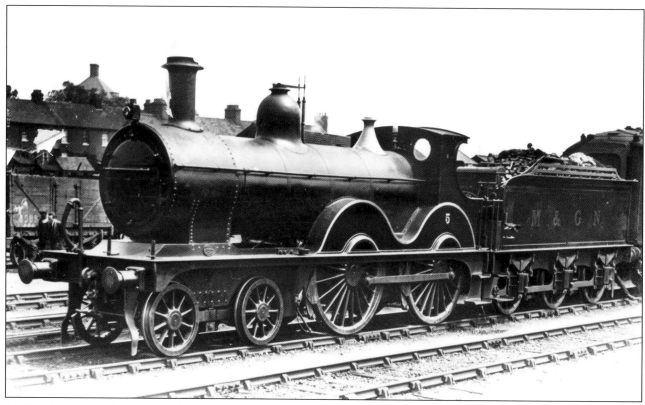

Midland & Great Northern Railway No.5 which became LNER D52 class 05 at Cromer Beach around the 1920s. This loco was withdrawn in July 1937.

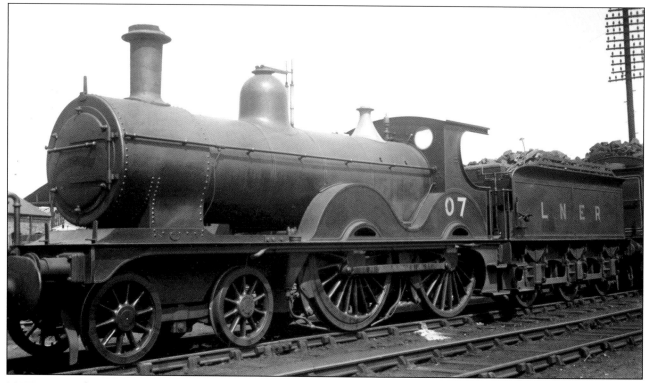

LNER D52 class 07 (ex M&GN No.7) is on shed at Melton Constable between October 1936, when its new number was applied, and June 1937 when it was withdrawn from service. Real Photographs

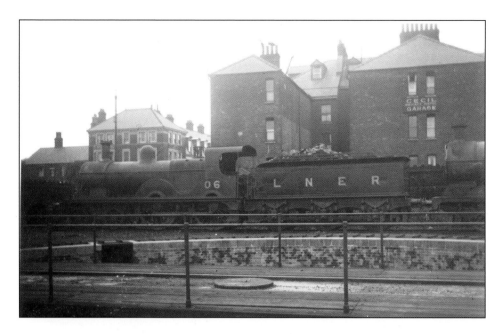

A dull photo of ex M&GN D53 class 06 (ex No.6) at Melton Constable shed in the late 1930s. Withdrawal took place in March 1944.

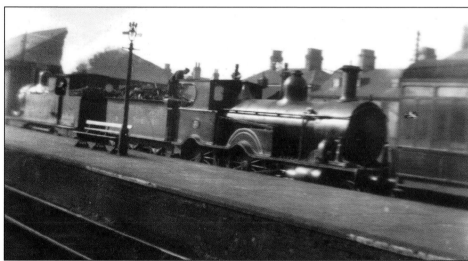

At Lowestoft Central at Easter 1927. The fireman is on the tender of M&GN 'A' class 31 preparing for the ensuing run. As this loco was withdrawn between 1933 and 1936 it never became LNER stock. Manoeuvring in the platform in front of 31 is F3 class 2-4-2T 8094 (later 7116) which was withdrawn in November 1947. E. Cotton

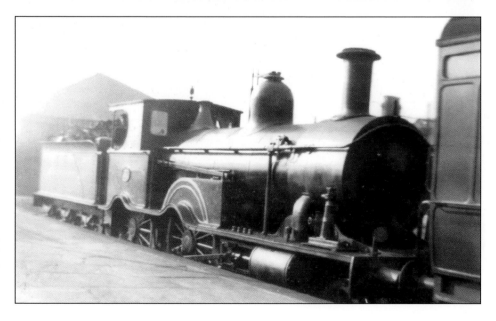

MGN 'A' class 31 is ready to depart from the MGN Bay platform at Lowestoft Central at Easter 1927.
E. Cotton

12

0-4-4 AND 2-4-2 TANKS

Formerly used on heavy suburban passenger trains the 0-4-4 tanks were latterly employed on branch passenger and Goods trains and were also used as shunting locos. The 2-4-2 tanks were primarily passenger locos.

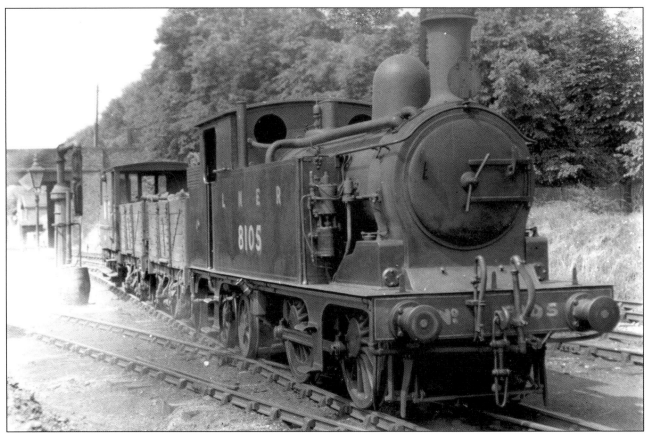

On 27 June 1936 G4 class 0-4-4T 8105 heads a short Goods train at Saffron Walden. This loco was withdrawn in April 1938.

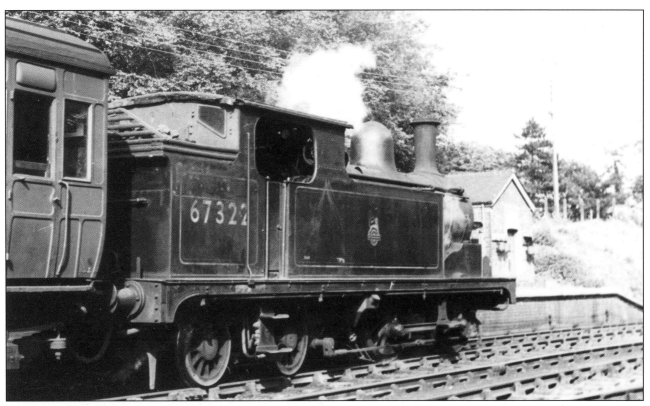

Cambridge shed's G5 class 0-4-4T 67322 (ex 2093) waits with a branch train at Saffron Walden on 12 September 1951. Passenger trains ended on 7 September 1964 with Goods following on 28 December the same year.

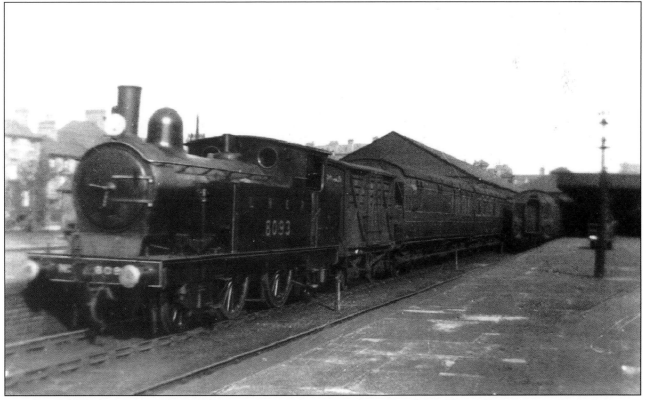

Now commences various 2-4-2Ts in the F classes. Norwich shed's F3 class 8093 (became 7115) has backed on to a London train at Lowestoft Central in August 1927. This loco was withdrawn during May 1948. E. Cotton

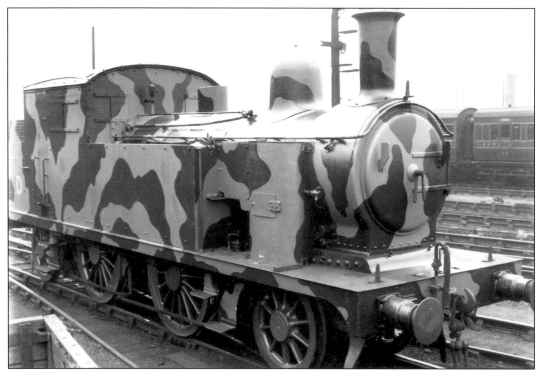

During the Second World War to counteract possible invasion from the Germans, eleven armoured trains were prepared by modifying existing rolling stock and locomotives. Four extra locos were also modified. The locos consisted of fourteen F4 class and one F5 class 2-4-2Ts. The eleven locos were lettered as were their trains but the four additional locos were only known as 'Spare' followed by a number. In June 1940 on display at Stratford shed following modification is F4 class 'D' (ex 7178 and later 7173). National Railway Museum 2085.

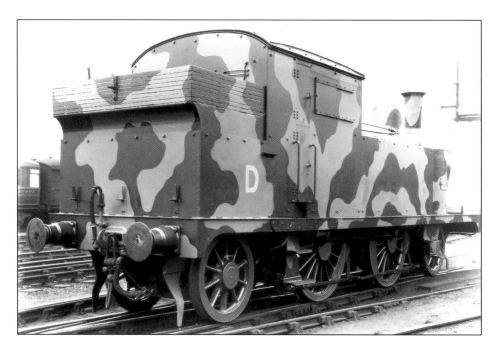

Another view of armoured F4 class 'D' at Stratford in June 1940. National Railway Museum 2056

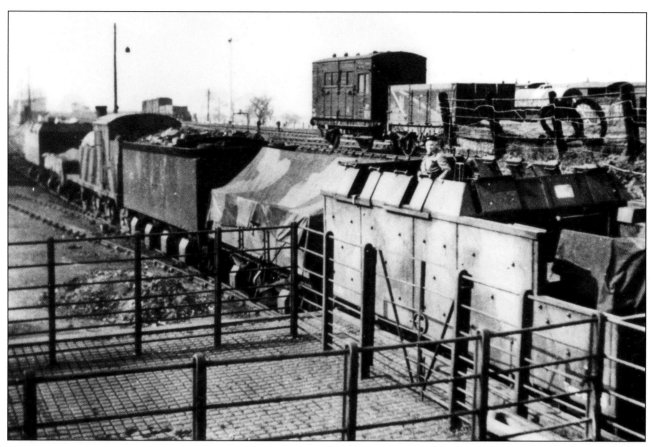

In February 1942 armoured train and F4 class 'D' is in the Cattle Dock sidings at Manningtree. Next to the loco is a Caledonian Railway bogie tender which has not been camouflaged. The train was based at Mistley at this time. G.Balfour Collection

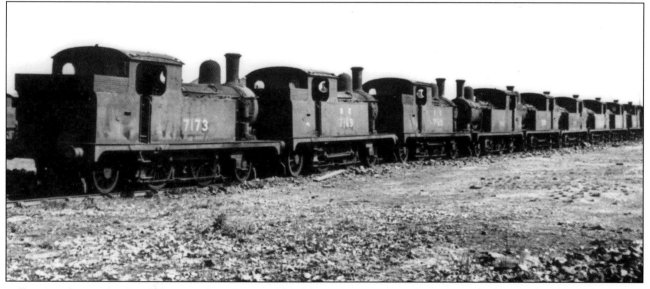

Following their return to the LNER the armoured locos were renumbered in 1946 but all were withdrawn in April 1948. Seen at this date is this line of ten F4 class locos awaiting scrapping at Stratford Works. From the left they are 7173 (ex7178 and 'D'), 7169 (ex 7173 and 'L'), 7180 (ex 7071 and 'H'), 7181 (ex 7072 and 'B'), 7170 (ex 7174 and 'Spare 4'), 7179 (ex 7189 and 'G'), 7159 (ex 7586 and 'Spare 1'), 7161 (ex 7111 and 'Spare 3'), 7168 (ex 7172 and 'A'), and 7172 (ex 7177 and 'Spare 2').

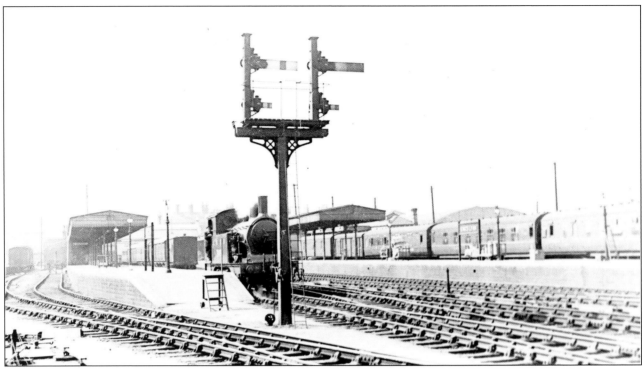

Around 1936 F5 class 7143 (later 7190) is on Station Pilot duty at Kings Lynn.

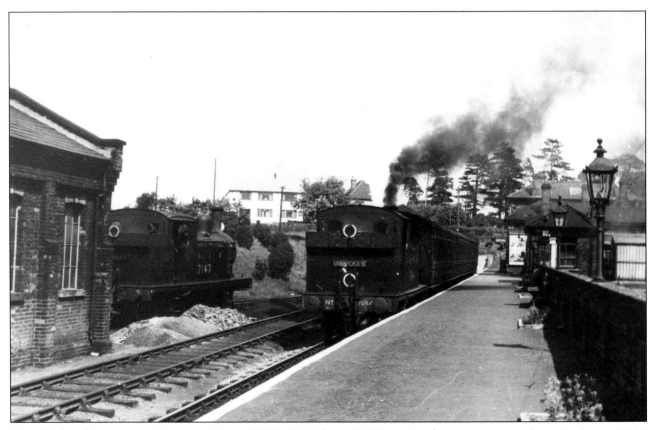

Two F5 class locos are at Ongar on 1 June 1938. 7144 (later 7191) awaits departure on a train to Epping as 7147 (later 7193) loiters in front of the loco shed.

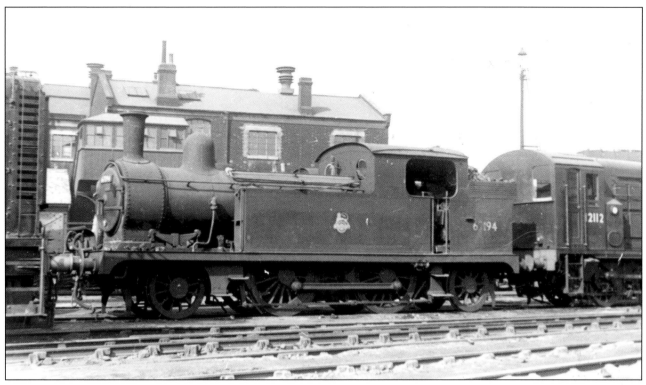

On 15 March 1953 Colchester's F5 class 67194 (ex 7781) is at Stratford shed surrounded by 350HP Diesel shunters one of which is 12112 which was allocated to Hornsey depot.

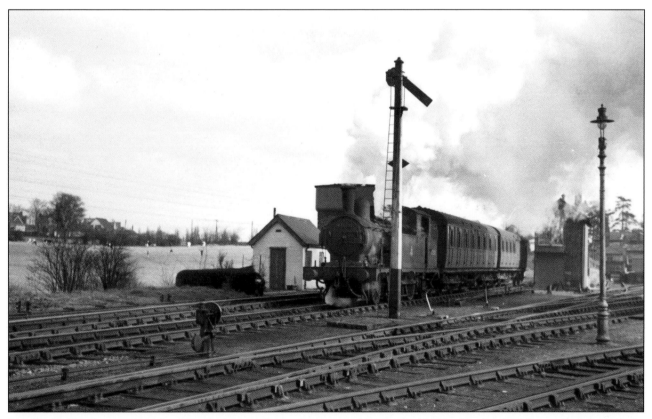

Stratford's F5 class 67200 (ex 7787) departs from Ongar on 13 March 1955 with the 12.27 pm (Sundays) train to Epping.

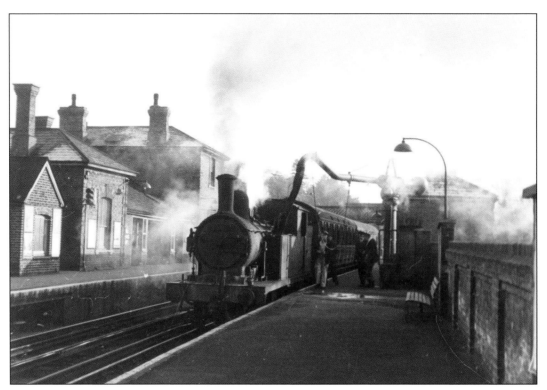

On 29 April 1956 Stratford's F5 class 67200 (ex 7787) takes water at Epping on arrival from Ongar.

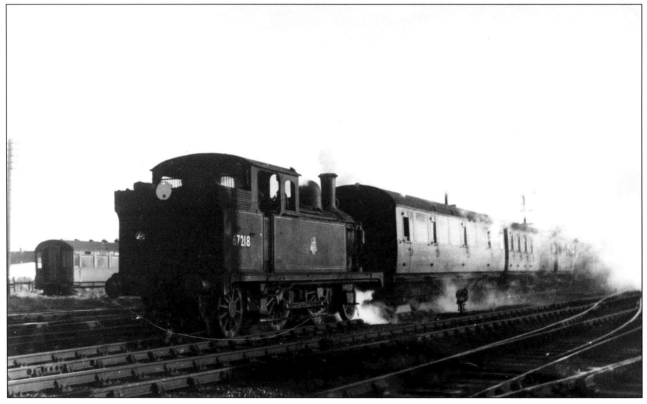

On 1 September 1951 Yarmouth Beach shed's F5 class 67218 (ex 7789) shrouds the surrounding area in steam as it makes a rousing departure from its home station which closed to all traffic on 2 March 1959.

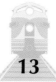

13

2-4-0s AND A 2-4-0 TANK

These worked local and branch passenger trains.

Lynn & Fakenham Railway 2-4-0 No.3 appears to be at Fakenham in the early 1910s. This loco, which started life as Cornwall Minerals Railway 0-6-0T No.3, was sold to the L&F by the GWR around 1900. Its side tanks were removed and it was converted to a 2-4-0 tender engine. It became GER and LNER property. Parts of the original were used in 0-6-0T 3A which became 95 and 095 ending life as J93 class 8485 in December 1947. This station closed to all traffic on 2 March 1959.

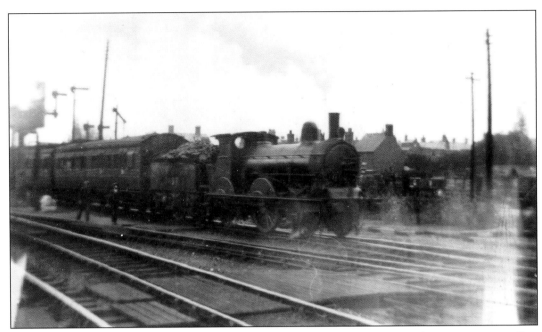

Norwich shed's E4 class 2-4-0 7487 departs from Beccles Junction with a Waveney Valley line train in August 1927. This loco was withdrawn in December 1929. E. Cotton

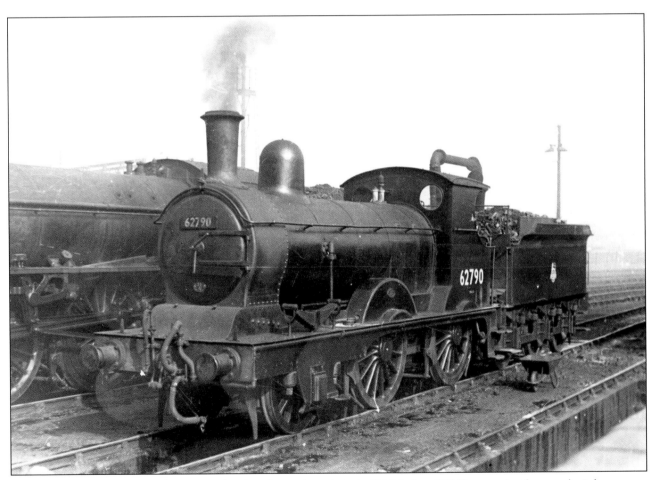

Cambridge shed's Westinghouse Brake fitted E4 class 2-4-0 62790 (ex 7503) rests in the yard at home on 19 September 1953.

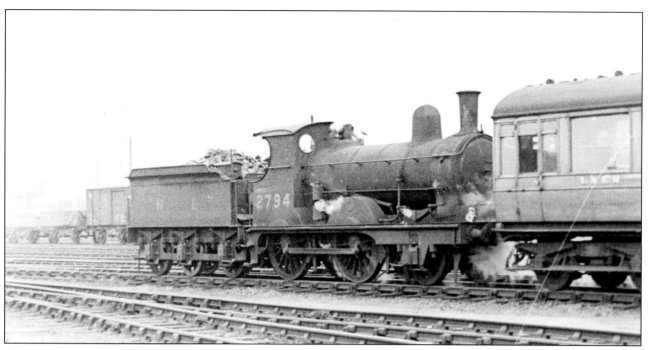

E4 class 2-4-0 2794 (ex7409) from Cambridge shed shunts in the extensive carriage sidings at its home station on 15 April 1947.

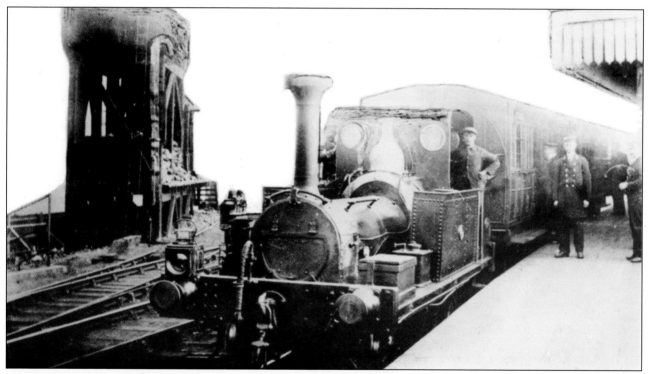

One of the three 2-4-0Ts owned by the Millwall Docks Co. waits to depart from North Greenwich on the Millwall Extension Railway on the Isle Of Dogs around 1900. These locos were locally nicknamed 'Coffee Pots' because of their tall chimneys. The Coal Stage and Water Tank are on the left. This line was taken over by the Port Of London Authority in 1909 and these locos worked the service until November 1922 with guards provided by the Great Eastern Railway. The last passenger train operated on 3 May 1926. North Greenwich station was used as a store until the mid-1960s. Pamlin Prints

14

AN 0-4-2 TANK AND 0-4-0 TANKS

These were shunting engines used in yards, as shed and works pilots, and in docks.

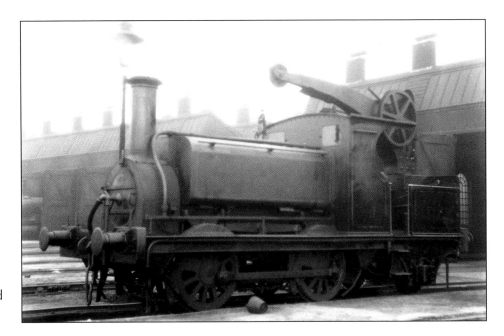

North London Railway 0-4-2 Crane tank 7217 (originally NLR 2896 and later 27217 and 58865) which appears to be devoid of any side number stands at home outside Devons Road shed in the mid-1920s.

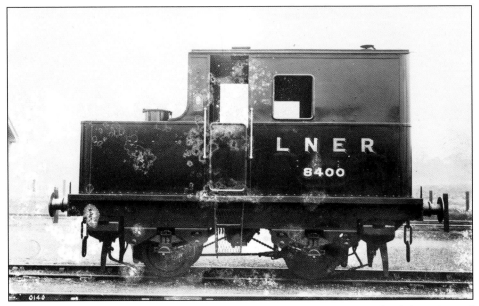

Y1/1 class 0-4-0 VBT 8400 (later 7772, 8130, and service No.37) built by Sentinel is at home at Lowestoft on 28 March 1940. F. Moore's Railway Photographs

The same loco Y1/1 class 0-4-0T 8400 shunts at Lowestoft Harbour at Easter 1927. E. Cotton

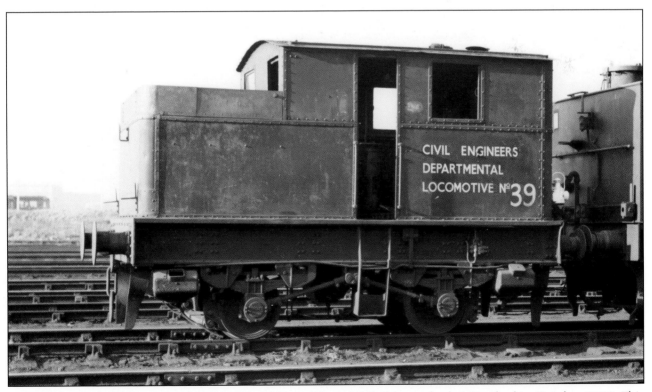

Y1/1 class 0-4-0T Departmental No. 39 (ex 8131, 7773 and 8401) is on shed at Stratford in October 1962. This loco normally worked at Chesterton Junction Engineers' yard. P. H. Groom

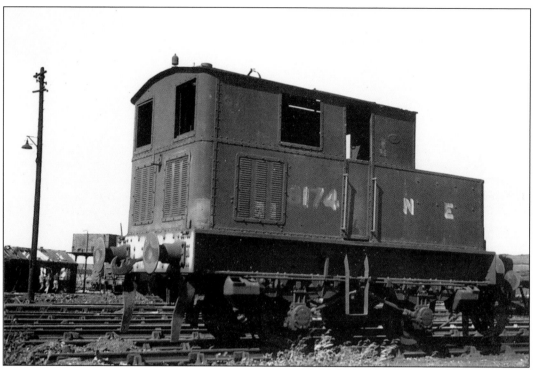

Y3 class 0-4-0T 8174 (ex 64) is at home at Colchester shed around 1947. Ken Brown

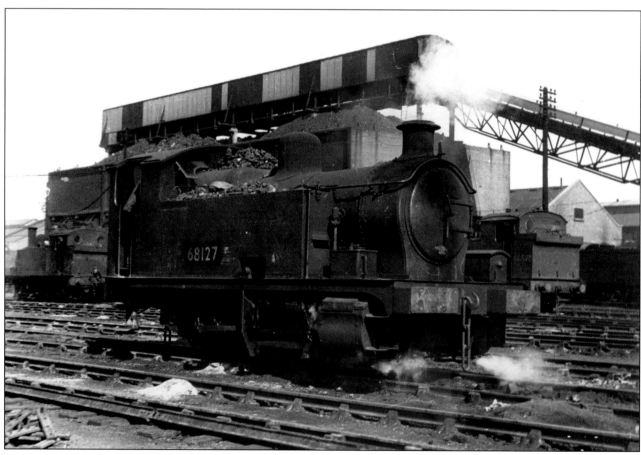

Y4 class 0-4-0T 68127 (ex 7226) is at home at Stratford shed on 21 July 1951.Two 0-6-0Ts of J67/69 class are visible, the right hand loco being J67 class 8520 (ex 7015) which is also at home.

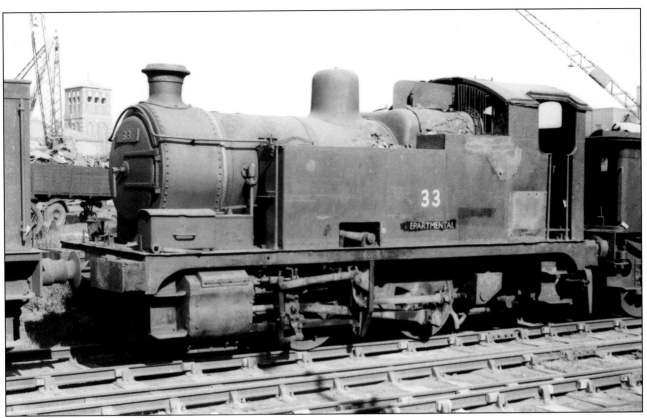

Y4 class 0-4-0T Departmental 33 (ex 68129 and 7210) which was withdrawn in December 1963 is in a line of withdrawn locos at Poplar in March 1964. This loco had been the pilot at Stratford Old Works. P. H. Groom

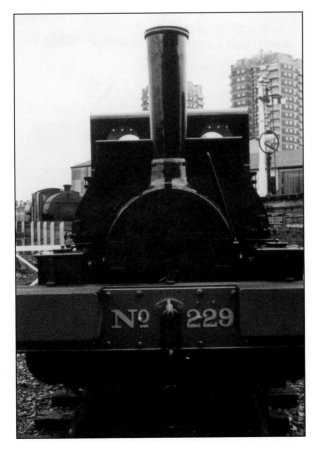

Preserved Y5 class 0-4-0ST Great Eastern Railway 229 at North Woolwich Station Museum on 25 March 1987. This loco was withdrawn by the GER in February 1917 and was sold to the Admiralty and worked at National Shipyard No.1 at Beachley Dock near Chepstow. From there it moved to nearby Fairfield Shipbuilding & Engineering Co. who became Fairfield-Mabey. I photographed this loco at their premises at Easter 1969. In the left background two 0-6-0STs are 29 (P 2000/1942) and RSH 7667/1950.

Maurice Dart

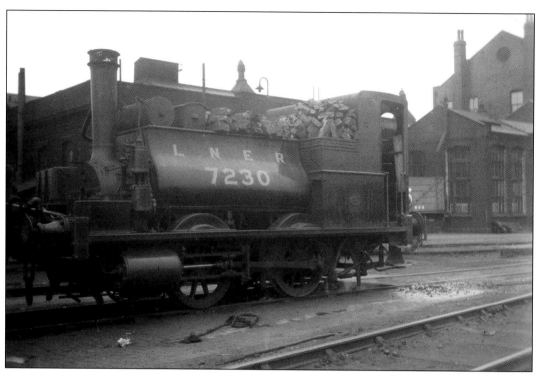

Y5 class 0-4-0ST 7230 (became 8081) in Service stock shunting at Stratford Old Works in the 1930s. When not in use it was kept near the Polygon shed at Stratford Works. As well as shunting at the Old Works it also carried out brake testing on coaches there. Withdrawal took place in April 1948.

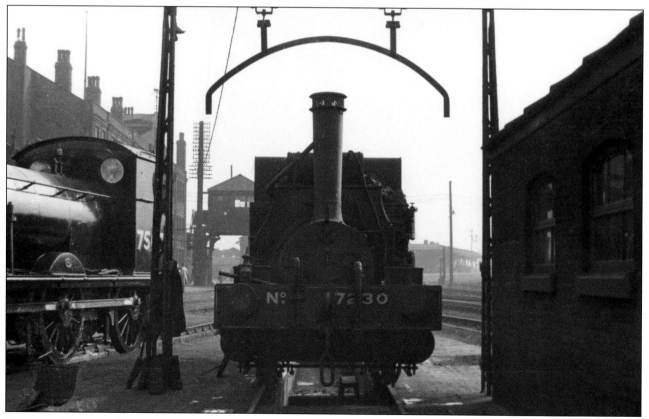

The same loco Y5 class 0-4-0ST 7230 stabled near the Polygon shed at Stratford Works on 11 March 1938.

Y10 class 0-4-0T 68188 (ex 8188, 7775 and 8403) shunts at home at Yarmouth Vauxhall on 31 August 1951. Officially this loco was not renumbered 68188 but some local person had added a chalked 6 at the left.

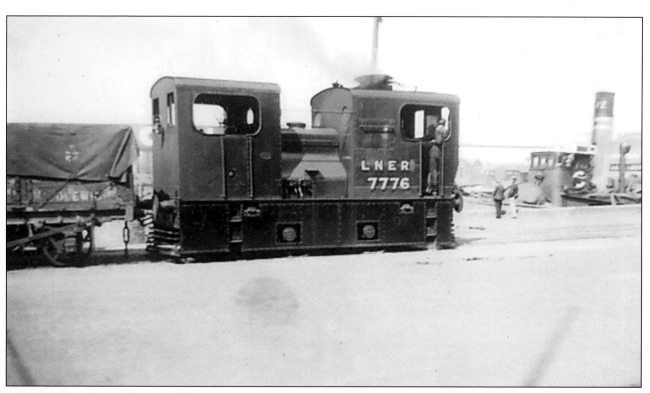

Yarmouth's Y10 class 0-4-0T 7776 (ex 8404 and later 8187) shunts on Yarmouth South Quay in the mid-1940s. Withdrawal took place in August 1948. R. Halliday

15

SHED SCENES, A STEAM RAILCAR AND PETROL LOCOS

A couple of scenes at sheds show the variety of locos present. The Steam Railcars worked branch passenger trains and the petrol locos worked and usually stayed in specific yards.

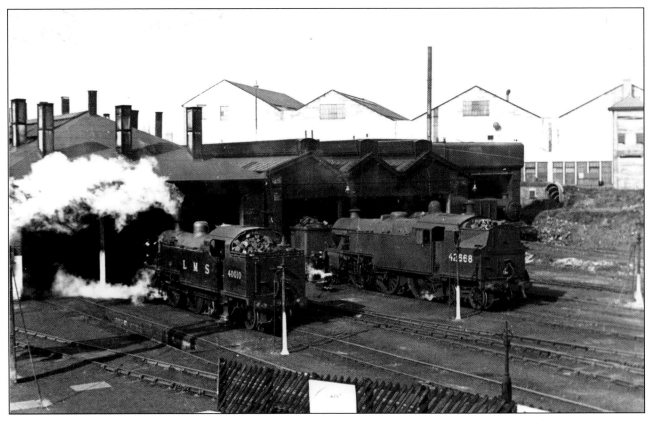

Locos outside Watford shed on 14 April 1949 are locally based Fowler 2P 2-6-2T 40010 and visiting 4P2-6-4T 42668 which was allocated to Stoke shed. Why is this loco at Watford?

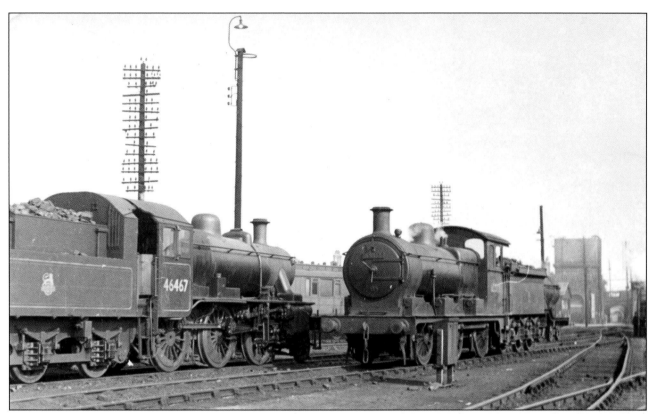

Two locos at home on shed at Cambridge on 19 September 1953 are Ivatt 2P 2-6-0 46467 and J17 class 0-6-0 65512. The Ivatt Mogul has large cabside numerals which suggests that it had been repainted at a Scottish works, also it is fitted with a small thin chimney.

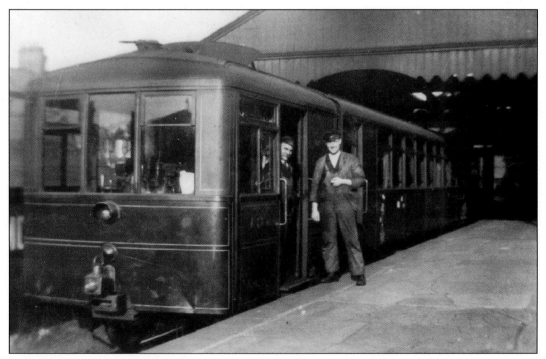

Sentinel-Cammell Steam Railcar 13E (later 43307) waits to depart from Lowestoft Central with the 5.40 pm to Yarmouth and Gorleston at Easter 1927. This Railcar worked until January 1940. E. Cotton

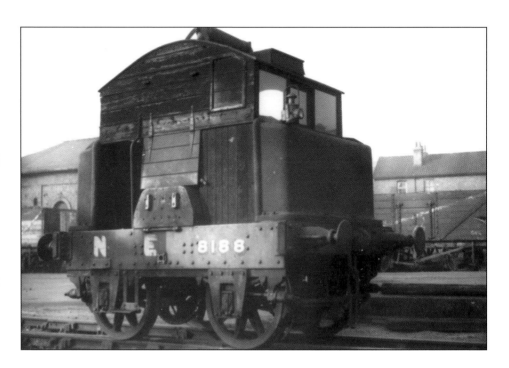

40 hp Y11 class 4w petrol loco 8188 (ex 8430, later 15098) rests between duties in Brentwood yard in the late 1940s. After its arrival at Brentford it was named PEGGY for a short while in 1925. The Locomotive Club of Great Britain/Ken Nunn Collection

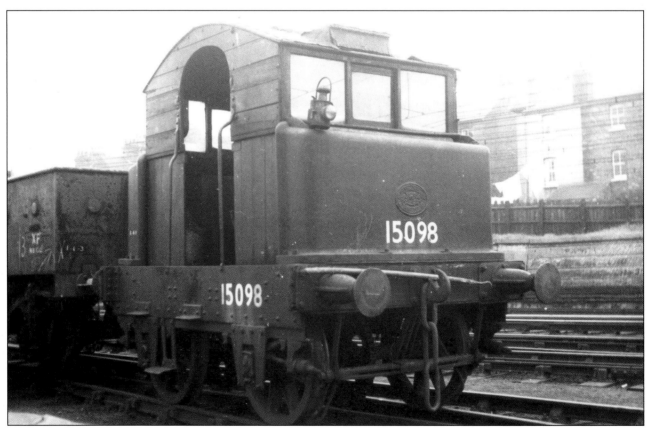

Around 1950 4w petrol loco 15098 (ex 8188 and 8430) stands coupled to a wagon in the yard at Brentwood.

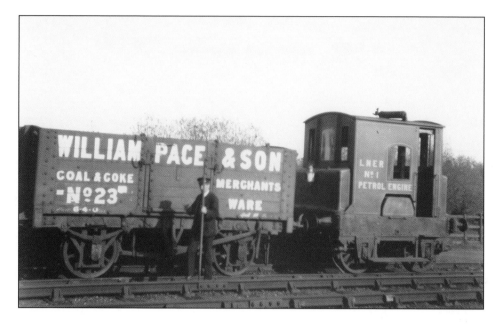

In the late 1920s Y11 class 4w petrol loco LNER No.1 Petrol Engine (later 8431, 8189 and 15099) stands coupled to 6-plank private owner wagon of William Page & Son No.23 in the yard at Ware around August 1929.

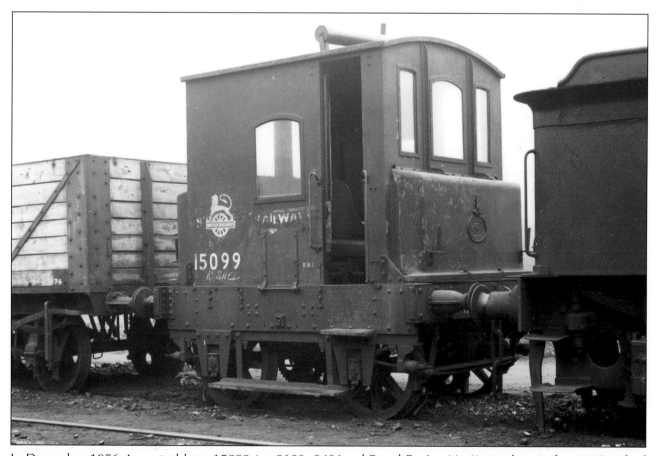

In December 1956 4w petrol loco 15099 (ex 8189, 8431and Petrol Engine No.1) stands out of use at Stratford shed following withdrawal the previous month. P. H. Groom

16

DIESEL SHUNTERS

These operated in shed, works, engineers' and Goods yards and at times at certain locations acted as Station Pilots and worked branch freight trains.

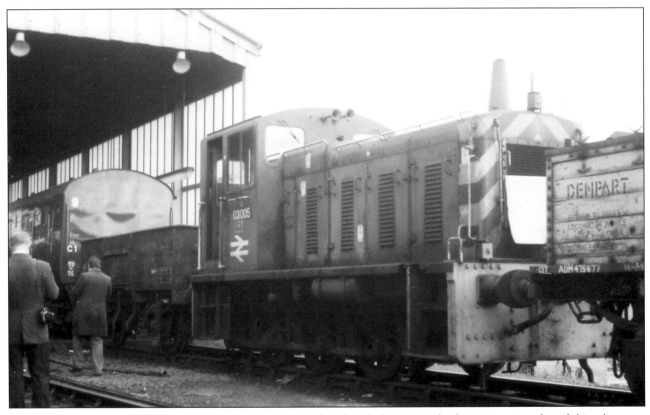

This section commences with a good selection of 204 hp diesel shunters which were quite plentiful in the area covered by this book. Cambridge's 03005 rests at home at Coldhams Lane depot on 4 April 1976. The loco is standing in front of a Denpart wagon ADM 475677 which had been converted from an ex-LMS 3-plank open wagon. Maurice Dart

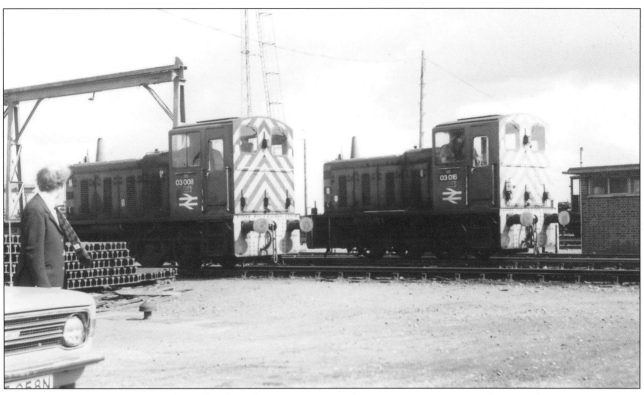

Taken against the light two of Cambridge's locos, 03008 and 03016 are acting as Pilots at Chesterton Junction Permanent Way depot on 4 April 1976. Maurice Dart

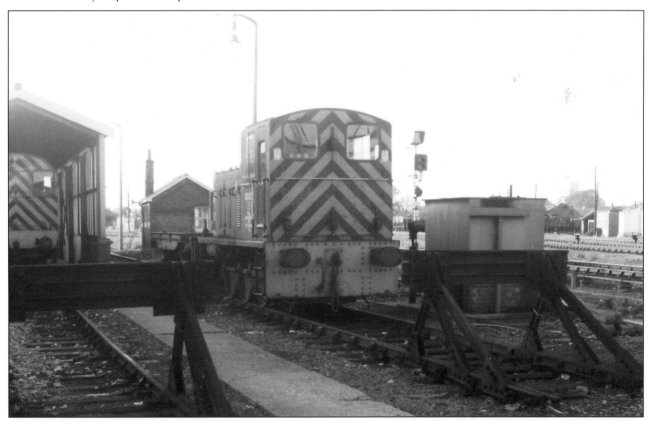

On 17 October 1976 two locos from March depot are stabled at the small depot at Kings Lynn. In the shed is 350 hp 08092 with 03017 outside.

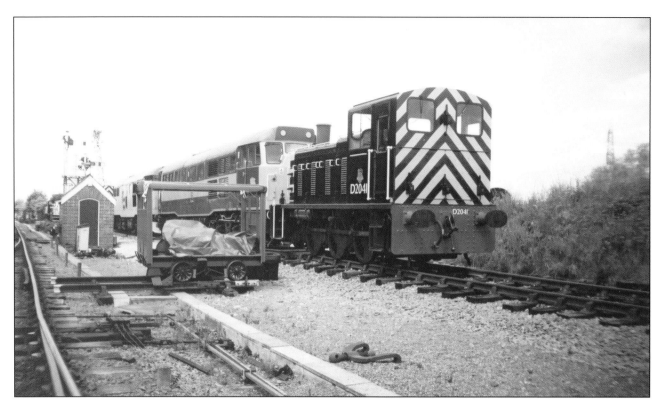

In preservation on the Colne Valley Railway at Castle Hedingham on 17 July 2002 is D2041 together with a Wickham Permanent Way Trolley. Behind the 03, two 1470 hp Class 31 A1A-A1As are 31255 and 31270.
Maurice Dart

Outside Colchester depot on 17 August 1988 is locally based 08772 CAMOLODUNUM together with D2059 which was on the way to its new home on the Isle of Wight at Haven Street on the Isle Of Wight Steam Railway. Maurice Dart

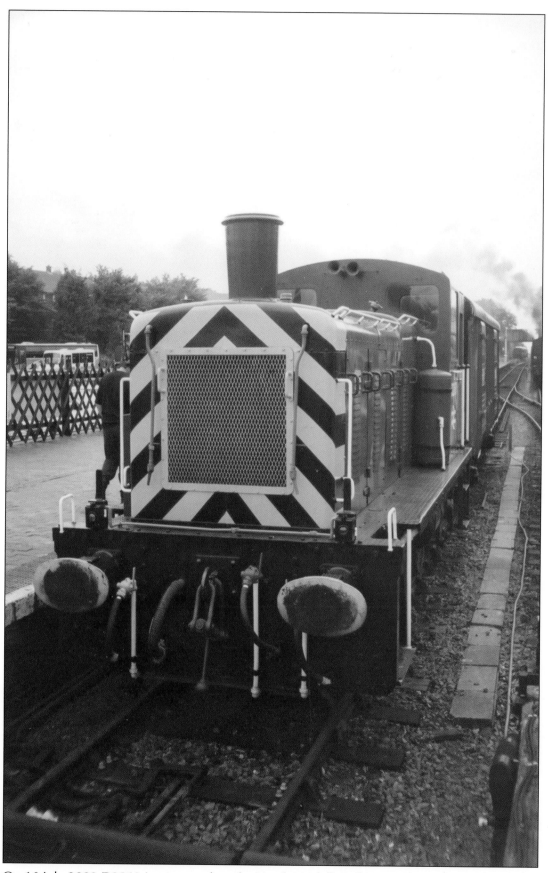

On 16 July 2002 D2063 is preserved on the North Norfolk Railway at Sheringham. Maurice Dart

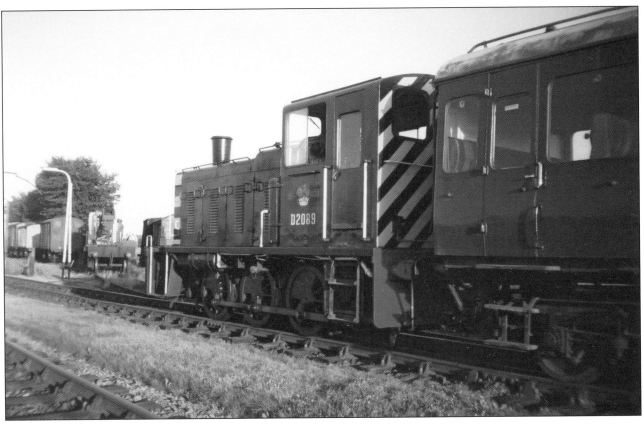

At Mangapps Farm on 15 July 2002, D2089 stands in the yard. Maurice Dart

Stratford depot's 03154 sits at home at the back of what was originally the 'Tank Shed' on 22 March 1980.
Maurice Dart

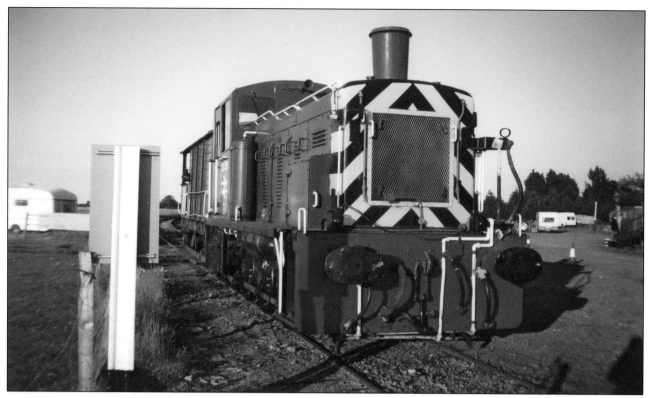

Mid-evening on 15 July 2002 03399 is coupled to a Brake van at Mangapps Farm ready to propel visiting enthusiasts along the 'New' Line. Maurice Dart

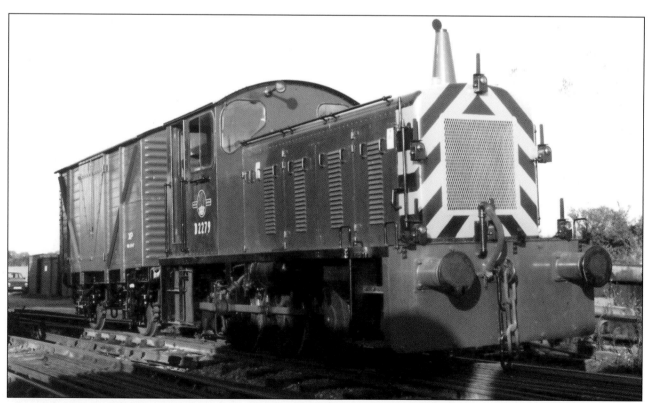

Class 04 204 hp D2279 is preserved at the East Anglian Railway Museum at Chapel & Wakes Colne on 4 October 1986. Maurice Dart

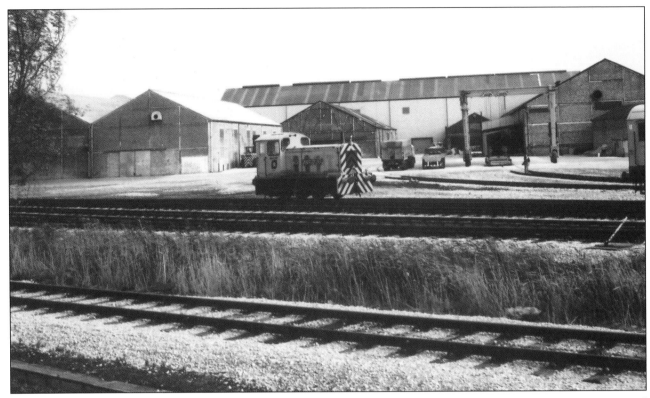

On 2 November 1991 Class 04 D2302 is at the Papworth Rail Distribution Centre near Ely. Following several moves in preservation it currently resides at Barrow Hill Roundhouse. Maurice Dart

Class 04 D2325 is tucked away inside one of the sheds at Mangapps Farm on 15 July 2002. Maurice Dart

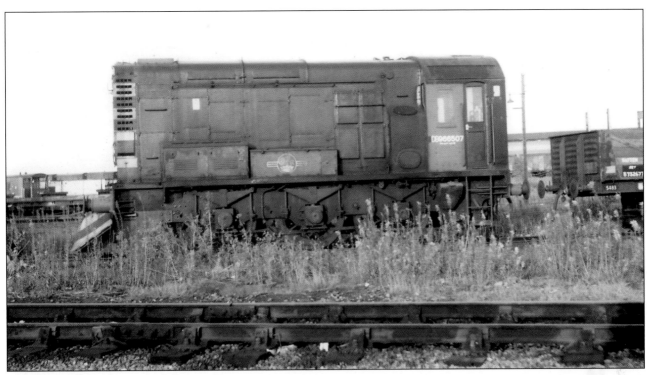

A batch of class 08 350 hp locos starts with DB966507 at March depot on 17 October 1976. This loco which had been D3006 had been converted to a snow plough. To its right is BR standard 22T Tube wagon B732677.

Maurice Dart

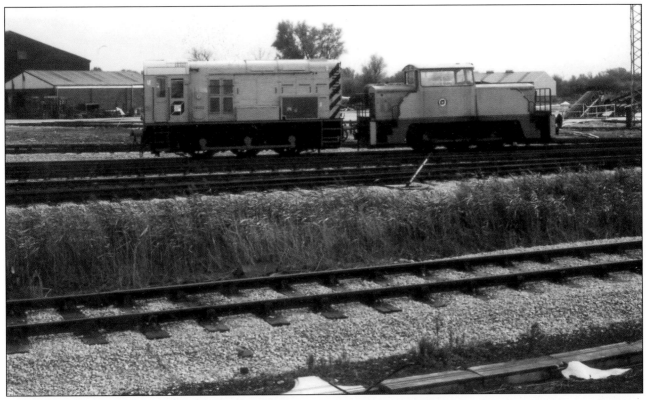

At Papworth Rail Distribution Centre on 2 November 1991, 08202 is keeping company with an unidentified Rolls-Royce/Sentinel 0-6-0DH loco. This loco moved to same company's site at Knowseley, near Prescot, St Helens. Maurice Dart

Norwich's 08498 is at home at Crown Point depot on 14 August 1988. Maurice Dart

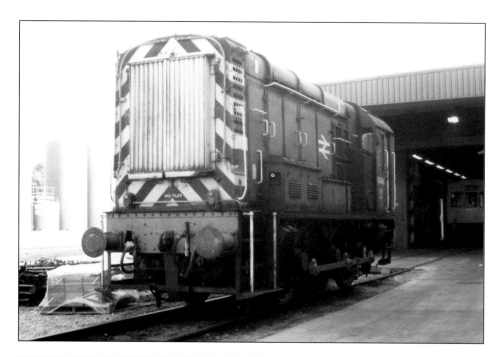

Stratford's 08521 sits in the Goods yard at Grays accompanied by BR standard 20T air-braked Brake van B954786 on 26 March 1987. Maurice Dart

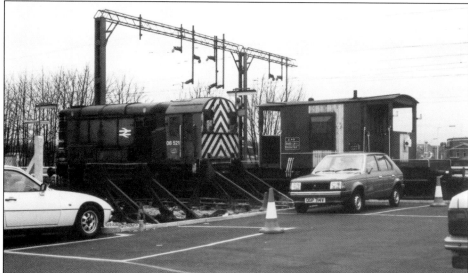

On 16 April 1989 08528 from Cambridge depot is in the yard south of the station at Hitchin. Maurice Dart

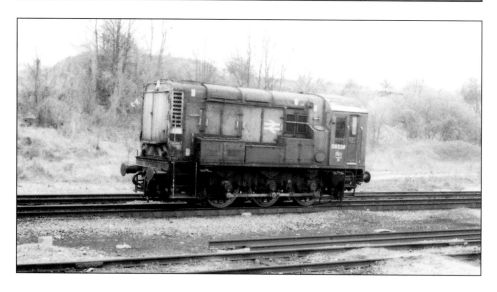

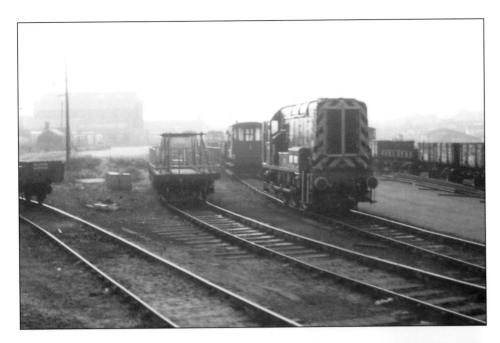

Cambridge depot's 08594 ELY stands in hazy evening sun in the yard at Bury St Edmunds on 9 October 1986.
Maurice Dart

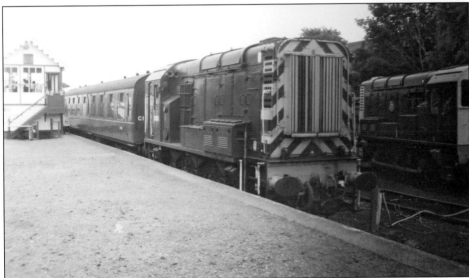

Two shunters at the north end of Sheringham station on the North Norfolk Railway on 16 July 2002 are D3935 (08767) and D3940 (08772). Maurice Dart

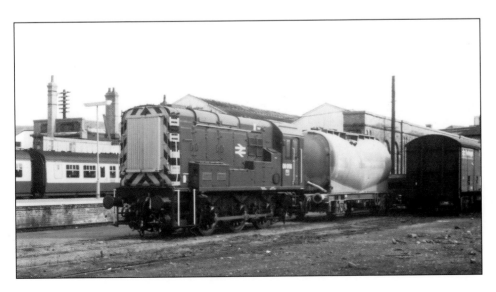

On 7 October 1986 very clean 08956 from Colchester depot stands in the yard at Lowestoft.
Maurice Dart

In a most awkward position in the yard at Castle Hedingham on the Colne Valley Railway on 17 July 2002 is class 10 D3476. After withdrawal this loco was sold by BR to English China Clays and was used at Fowey Jetties where I saw it on a number of occasions. This loco has since been scrapped. Maurice Dart

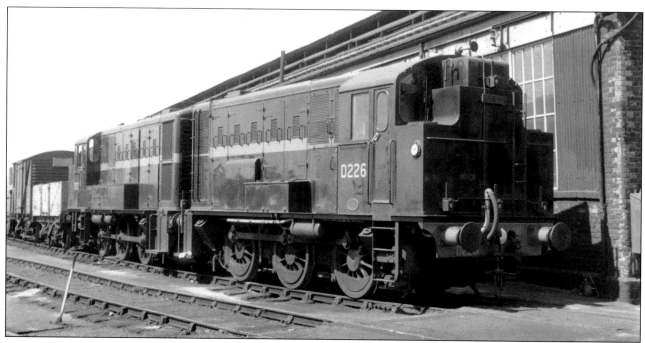

Two experimental 500 hp shunters built by English Electric were loaned to BR for trials. Both are at Stratford depot in Spring 1959. Diesel Electric D226 has been preserved on the Keighley & Worth Valley Railway where it has been named VULCAN. Diesel Hydraulic D227 which was unofficially named BLACK PIG was sold to Robert Stephenson & Hawthorns who scrapped it by July 1964. Transport Treasury

MAIN LINE DIESELS

These have worked all types of trains over main and secondary routes. To save repetition the power and wheel arrangement is only quoted for the first illustrated member of each class.

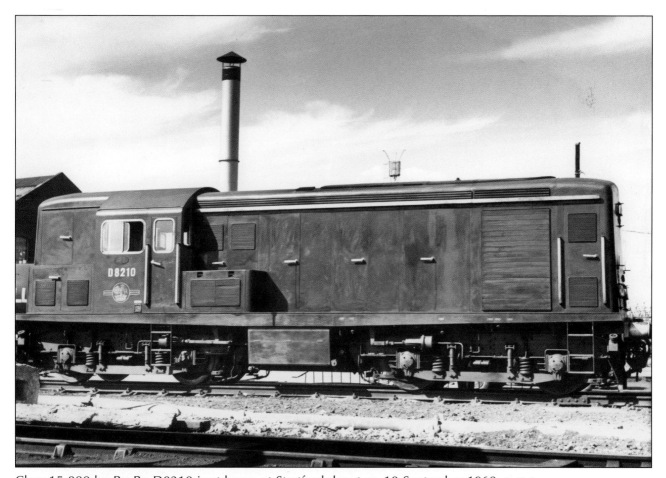

Class 15 800 hp Bo-Bo D8210 is at home at Stratford depot on 18 September 1960. R. K. Evans.

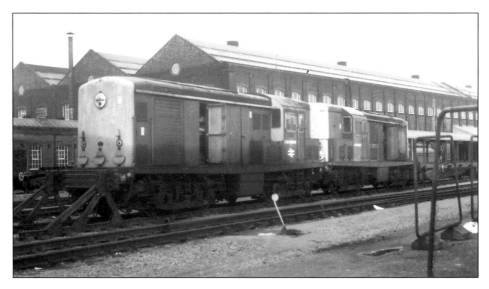

After withdrawal some class 15 locos were converted for use as Train Heating Units. Two of these at Stratford Depot on 24 June 1978 are ADB968000 (ex D8243) and ADB968003 (ex D8203).

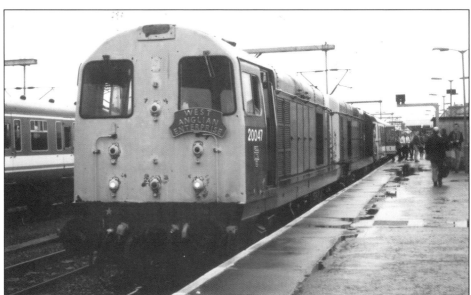

On 29 September 1990 during the West Anglia Gala Day a special train operated from Cambridge to Fen Drayton. In foul weather it awaits departure from Cambridge hauled by Toton allocated class 20 1000 hp Bo-Bos 20047 and 20004.

Maurice Dart

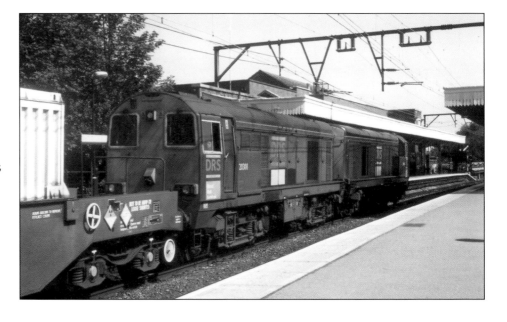

Two of Carlisle Kingmoor's class 20s, 20308 (ex 20187) and 20306 (ex 20131) haul a Nuclear Flask train east through Shenfield on 1 July 2002.

Maurice Dart

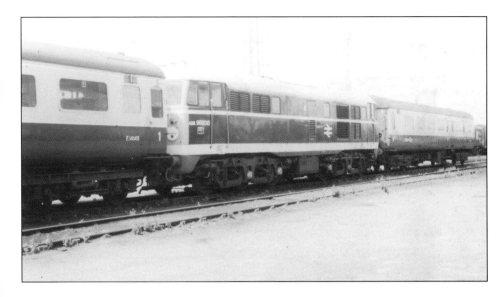

In the Carriage sidings at Yarmouth Vauxhall on 21 July 1980 is class 31 1470 hp A1A-A1A ADB968013 (ex 31013) which had been converted to an un-powered Carriage Heating Unit. The bright sun is reflecting off the loco's white roof. To its left is BR Brake First carriage E14145. Maurice Dart

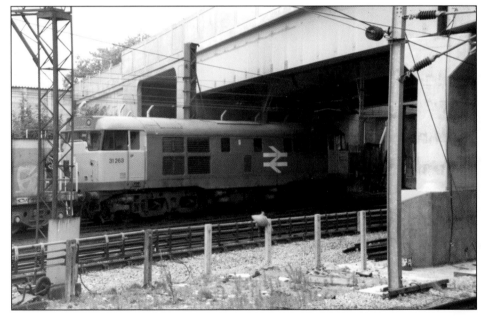

Stratford's class 31 31263 takes a freight through Barking on 16 July 1990.

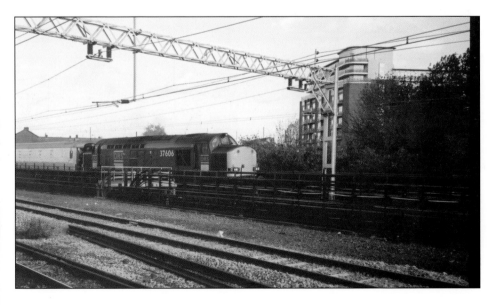

Carlisle Kingmoor allocated 1750 hp Co-Co class 37 37606 (ex 37508 and 37090) leads an engineering train through Stratford on 30 October 2007. Maurice Dart

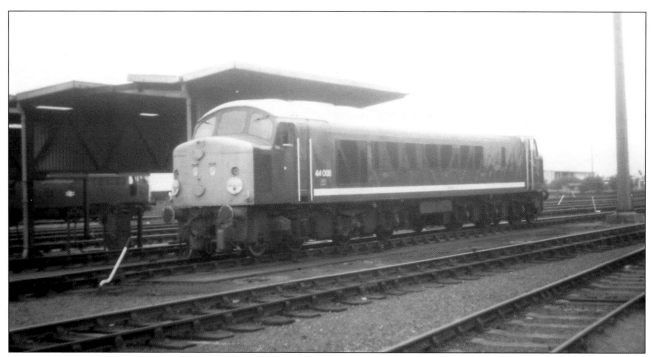

Although reported as being stored at Derby Works from November 1979 Class 44 2300 hp 1-Co-Co-1 44008 which was formerly named PENYGHENT is on March depot mid-evening on 18 July 1980. This loco is preserved at Peak Rail. Maurice Dart

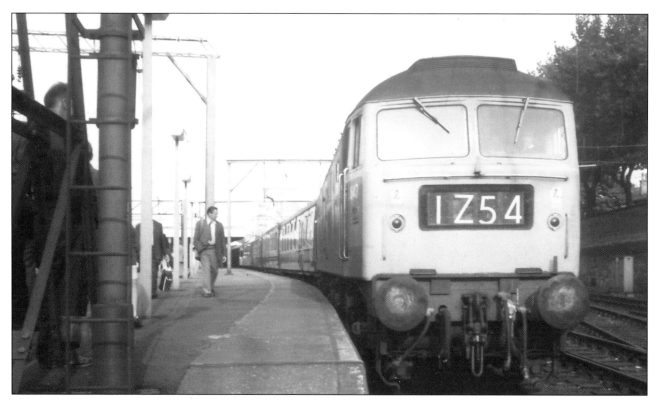

On 3 September 1972 Cardiff Canton's class 47 2750 hp Co-Co 1647 (became 47063) waits to depart from Southend Central on the return leg of a BR Mystery Tour from Plymouth. I had surreptitiously been advised of the train's destination and this was my first venture into East Anglia properly. The train traversed a different route around north and east London in each direction. Maurice Dart

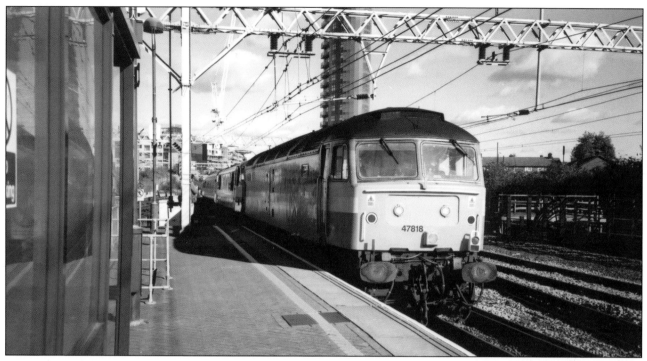

Just after midday on 30 October 2007 Norwich based Class 47 47818 (ex 47663 and 47240) propels Norwich's failed class 90 Electric loco 90006 MODERN RAILWAYS MAGAZINE. ROGER FORD out of Stratford on a train to Norwich. Maurice Dart

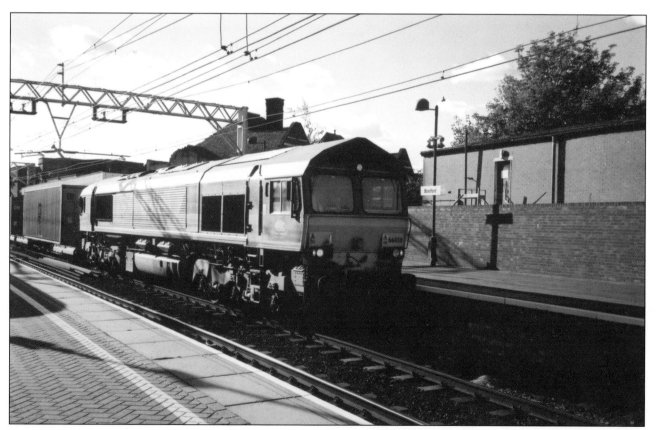

Toton's class 66 3200 hp Co-Co 66050 heads a container train east though Stratford around 13.00 hr on 30 October 2007. Maurice Dart

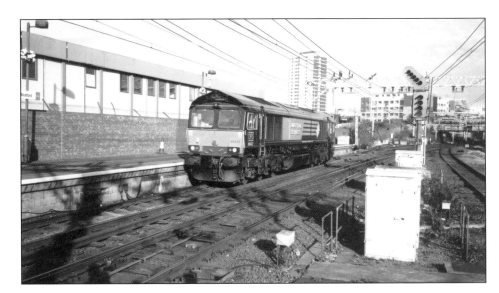

DRS class 66/4 66422 runs eastwards through Stratford on 26 November 2007. Maurice Dart

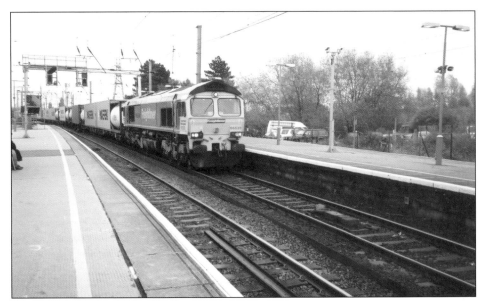

Freightliner's class 66/5 66533 SENATOR EXPRESS heads a container train west though Manningtree on 31 October 2007.
Maurice Dart

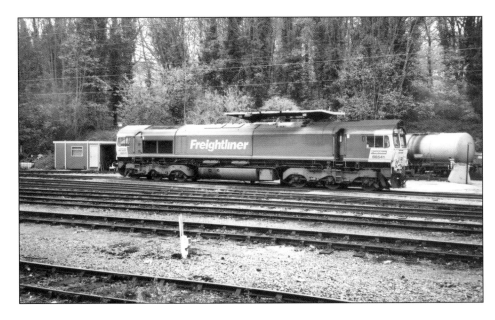

By the fuelling point at Ipswich Depot on 27 November 2007 is Freightliner's class 66/5 66541. Maurice Dart

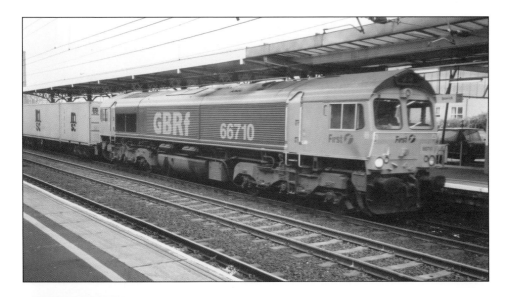

GBRF's class 66/7 66710 takes a westbound container train through Ipswich on 27 November 2007. Maurice Dart

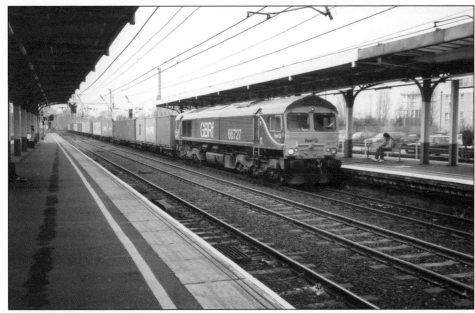

On 27 November 2007 a container train hauled by GBRF's class 66/7 66727 heads west through Ipswich. Maurice Dart

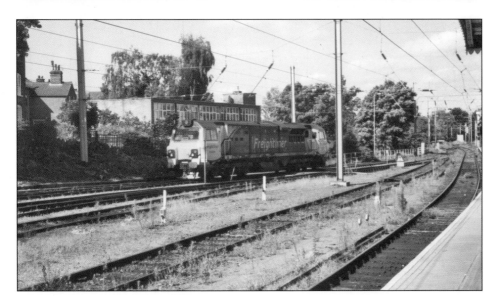

Taken against the light, Freightliner's Powerhaul 3700 hp Co-Co class 70 70009 stands ready to depart from Ipswich Depot to pick up a train on 1 September 2011. Maurice Dart

18

ELECTRIC LOCOS

These worked passenger and container trains on main electrified routes.

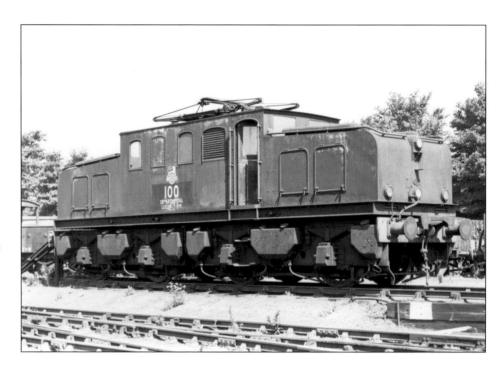

North Eastern Railway class EB1 (later EF1) 1500V 1256 hp Bo-Bo OHW DC Electric Departmental 100 (previously 26510 and 6498) stored out of use in Goodmayes Down yard in June 1962. P. H. Groom

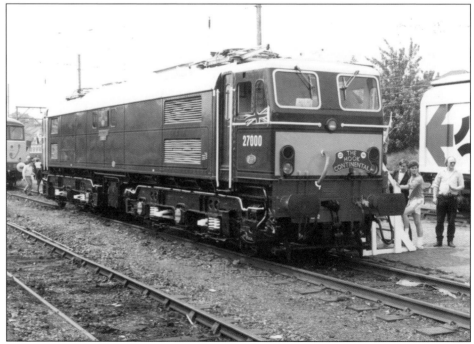

EM2 class 1500V OHW DC Bo-Bo Electric 27000 ELECTRA on display at an Open Day at Ilford Depot on 20 May 1989. This loco was sold to Dutch Railways on 22 September 1969 and was withdrawn by them on 14 June 1986. It returned to the UK on 15 July 1986 and can be seen at the Midland Railway Centre at Butterley.

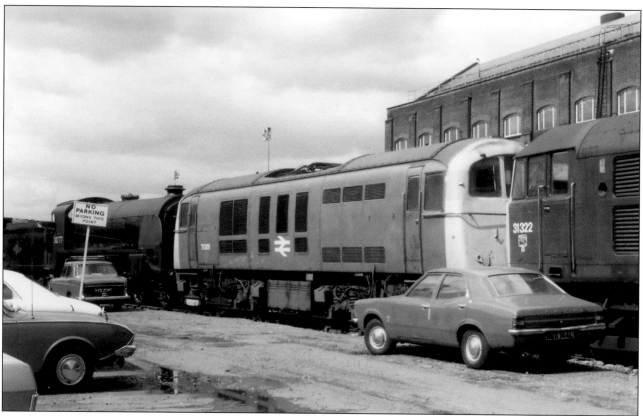

On 24 June 1978 2300 hp Bo-Bo OHW/3rd Rail Class 71 Electric 71001 is at Stratford depot awaiting forwarding to Doncaster Works for refurbishment for preservation. To its rear is preserved King Arthur class 4-6-0 30777 SIR LAMIEL with Class 31 31322 from March depot at its front. Maurice Dart

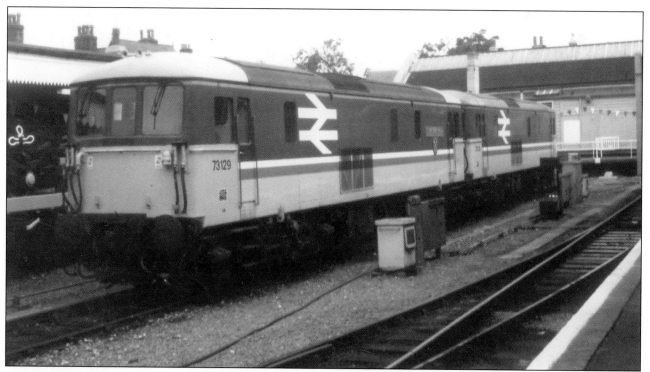

1420V Bo-Bo class 73 Electro-Diesels 73129 CITY OF WINCHESTER and 73103 are at Kings Lynn on 29 September 1990 where they were on display for the West Anglia Gala Day. Maurice Dart

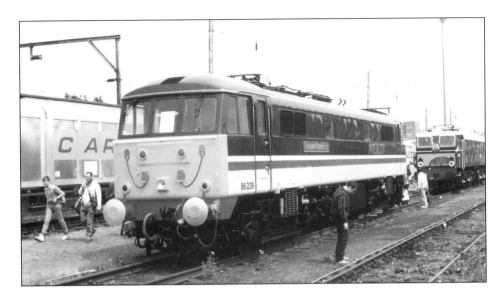

On 20 May 1989 25 KV Bo-Bo Class 86 86238 'EUROPEAN COMMUNITY' is on display at the Ilford Depot Open Day.

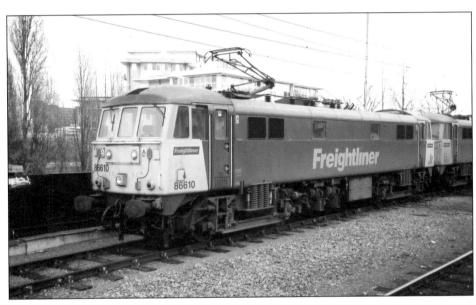

Freightliner's class 86s 86610 (ex 86410 and 86010) and 86638 (ex 86438 and 86038) are stabled at Ipswich on 27 November 2007. Maurice Dart

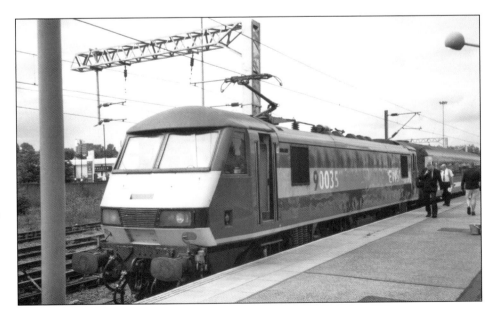

On 1 September 2011 Freightliner's 25 KV 5000 hp Bo-Bo class 90 90035 waits to depart from Norwich with the 12.30 to Liverpool Street. This loco had replaced a failed Norwich class 90. Maurice Dart

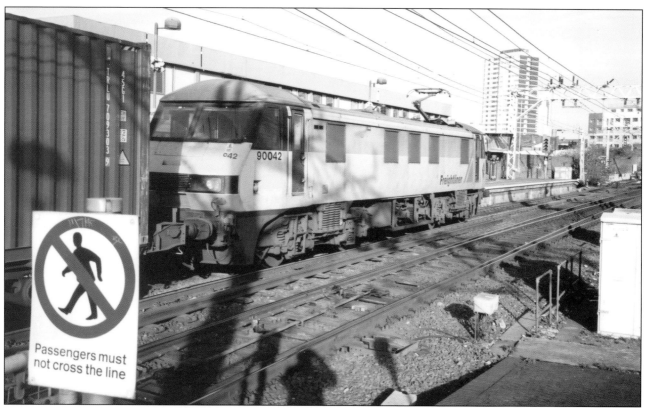

Freightliner's class 90 90042 takes an eastbound container train though Stratford on 26 November 2007.

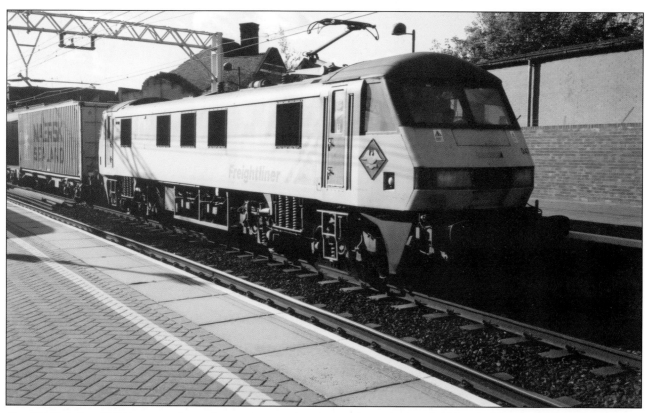

On 30 October 2007 an eastbound container train passes through Stratford hauled by Freightliner's class 90 90047.

19

DIESEL AND ELECTRIC MULTIPLE UNITS AND A CARRIAGE

I do not normally include many photos of these in my books but in this volume there is quite a selection, mainly to illustrate some unusual locations and workings. My knowledge of makers and type details along with their complex numbering and renumbering is minimal so please excuse the lack of this information in the captions. The main idea is to show some of these trains at some rare locations. The DMU's and EMUs are in separate sections each arranged alphabetically.

The driver changes ends on a Metro-Cammell DMU at Cromer (Beach) which had formed the 15.00pm departure from Sheringham to Norwich on 3 October 1986. The small loco shed which was on the far left hand side of the yard has been demolished. Maurice Dart

On 14 June 1983 a special visit to Crown Point depot was arranged for members of a party on an Inside Track holiday. By a special arrangement empty Sprinter 156416 which came off the depot picked up the participants at Crown Point Staff Halt to return them to Norwich (Thorpe) station. The Sprinter then formed a service to Lowestoft. Maurice Dart

Hertforshire Railtours's 'Wymondham Willows' formed from an 8-car DMU is stopped at Dereham on the line which originally extended to Wells-on-Sea on 28 November 1987. Maurice Dart

The 'Orwell Docker' Railtour Formed by a Metro-Cammell DMU, arranged by The Branch Line Society is almost at the limit of the usable line at Fen Drayton on 15 April 1989. Maurice Dart

On 15 August 1988 the shuttle service to Sheringham awaits departure from Holt formed by a German (WMD) built Railbus 79960. Maurice Dart

The Branch Line Society's 'Orwell Docker' Railtour Metro-Cammell DMU is at the BR Limit of Operation on the Ipswich Docks branch which descended steeply behind and across the road from Ipswich station on 15 April 1989. Maurice Dart

A Metro-Cammell DMU departs from Reedham on a service from Yarmouth to Norwich on 13 August 1988. Maurice Dart

A Cravens 2-car DMU has arrived at Sheringham on 3 October 1986 with the 11.55am departure from Norwich.
Maurice Dart

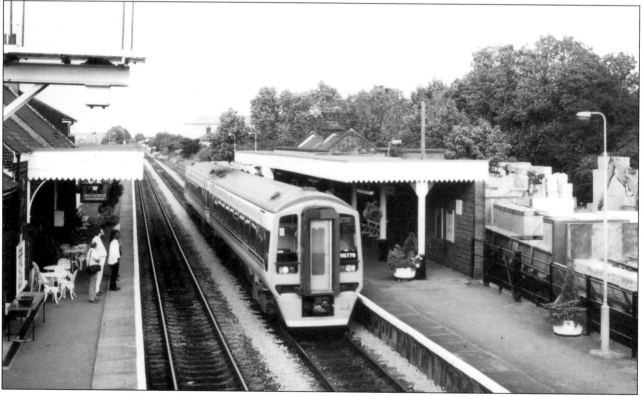

Sprinter 158779 at Wymondham working a Norwich to Liverpool Lime Street service on 10 August 1991. Maurice Dart

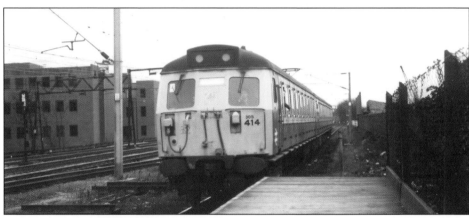

Two EMU's cross at Ockenden as a service from Tilbury departs for Upminster on 26 March 1987. Maurice Dart

EMU 305414 enters Romford on a service from Upminster on 26 March 1987. Maurice Dart

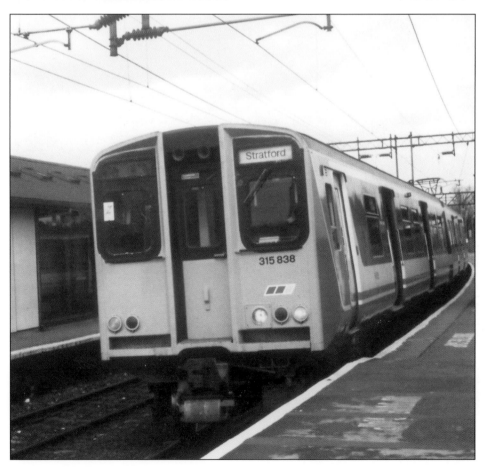

Due to engineering work closing the normal route from Liverpool Street to Seven Sisters on 14 April 1990 a special service was operated to that station from Stratford. These trains used two normally non-passenger curves from Tottenham South Junction to South Tottenham East Junction and from South Tottenham West Junction to Seven Sisters Junction so presenting an opportunity to ride over two short but very rare sections of route. EMU 315838 waits to depart from Seven Sisters with the 13.04 service to Stratford. Maurice Dart

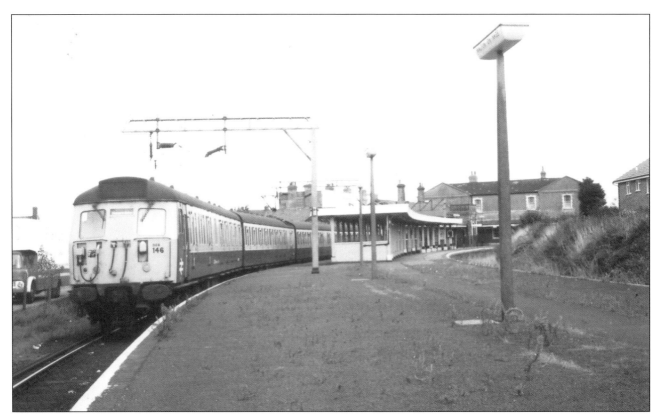

On 6 October 1986 EMU 308146 has arrived at Walton-On-Naze with the 14.05 service from Thorpe-Le-Soken. It will form the 14.34 return service. Maurice Dart

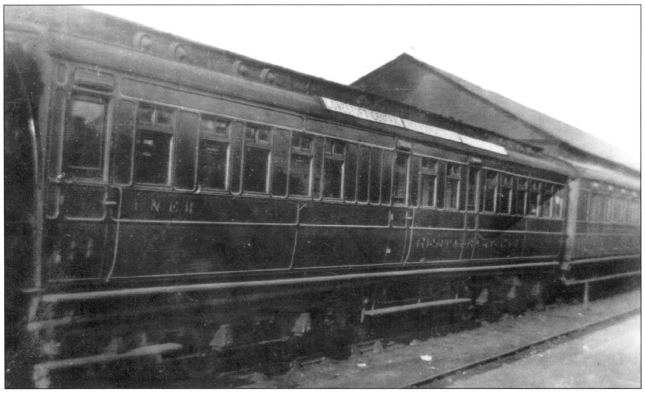

A twelve-wheeled restaurant car for the Lincoln, Doncaster, York and Peterborough service in the sidings at Lowestoft Central in August 1927. E.Cotton

20

A TUNNEL, A VIADUCT AND INFRASTRUCTURE

This section is self-explanatory. Infrastructure locations are arranged alphabetically.

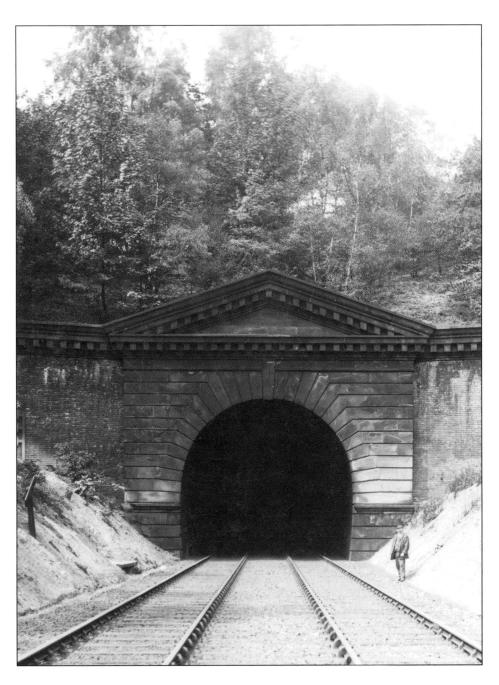

The south portal of 1mile 230yd Watford New tunnel in the early twentieth century. F. Moore's Railway Photographs

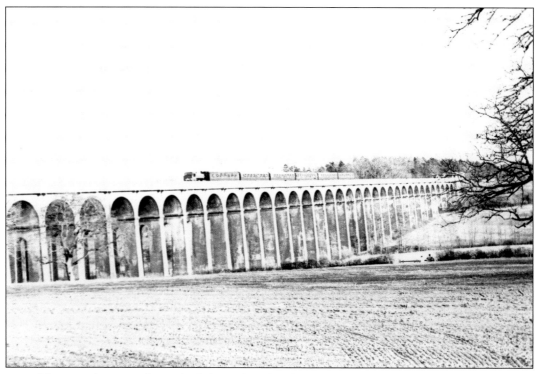

529yd long Welwyn viaduct which has a height of 89ft and contains 40 piers, as seen in the late 1960s. The viaduct spans the valley of the River Mimram. Crossing the viaduct is preserved J52 class 0-6-0ST 1247 (was 8846 and 4247) in the early 1960s.

In pride of place surveying all below it, above the Up platform at Chelmsford on 27 November 2003 is the disused Great Eastern Railway Signal box. Maurice Dart

Work in progress on bridge 156 at Chigwell station on 8 March 1927. From 22 November 1948 this station became part of LTE's Roding Valley line to Hainault.

On 2 November 1991 Badger Railtours' 'Fletton Avoider' is at the BR limit of working on the branch line into Ciba-Geigy at Duxford. The Metro-Cammell DMU is at the buffers and a Bruff Road/Rail vehicle is in the yard on track. Maurice Dart

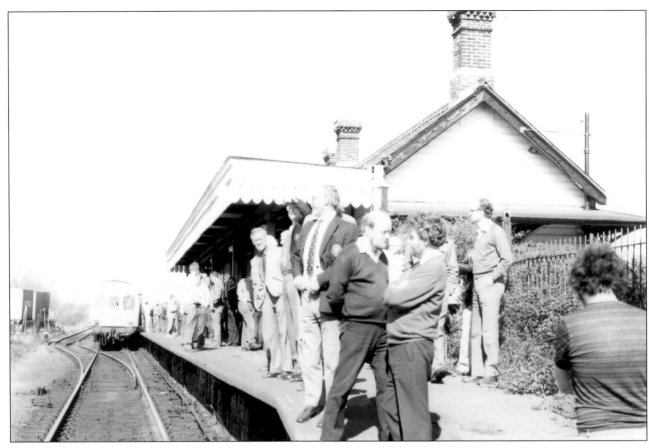

The Branch Line Society's 'Orwell Docker' Railtour covered the branch line to Felixstowe East Docks on 15 April 1989. Before proceeding to the docks the Metro-Cammell DMU is stopped at the closed Felixstowe Beach station for photographic opportunities. Maurice Dart

The DMU used for Badgers Railtours's Fletton Avoider' is at the end of the sidings which served Barrington's Cements at Foxton on 2 November 1991. Maurice Dart

The line from the north end of the quay at Harwich towards the station on 1 November 2007. Maurice Dart

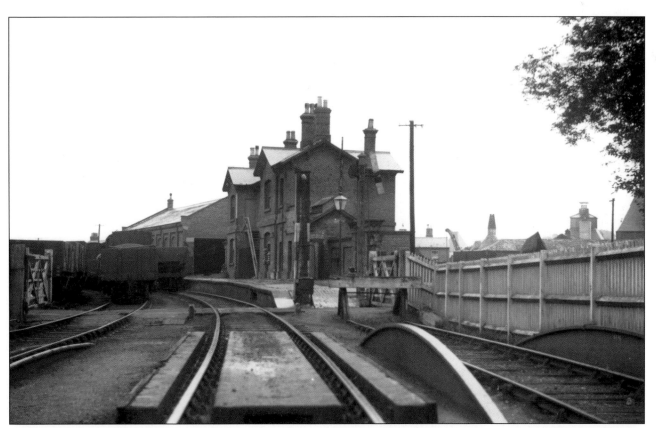

Hertford North station, the terminus of the line from Stevenage, which closed completely on 18 June 1951. The photo is probably from the 1930s.

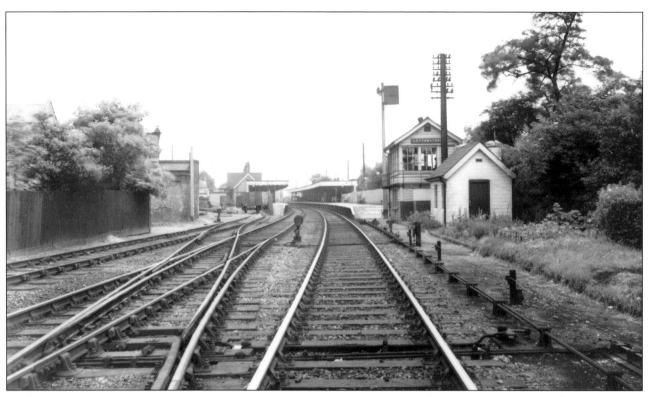

Looking west at Leytonstone on 1 July 1937. From 5 May 1947 this station became part of the LTE line to Epping.

Looking towards the semi-derelict station at Middleton Towers from a special train on 29 September 1990. This station, on the line to Dereham, closed to passengers on 9 September 1968. Maurice Dart

Plenty of rails laid into the stonework remained at the north end of Mistley Quay on 31 October 2007.

Rails remained embedded in the road at the south end of Mistley Quay on 31 October 2007. Towards the far left of the photo, from a reversal the track ascended a steep incline to reach the main branch line immediately south of the station. The incline replaced an earlier circuitous line which passed below the main branch line. Internal security prevented me from reaching the foot of the incline. Maurice Dart.

A view from the window behind the driving cab on the 11.55 from Norwich to Sheringham DMU which is crossing a service to Norwich at North Walsham on 3 October 1986. Maurice Dart

Roundwood Halt between Harpendon and Redbourn on the Midland Railway's Hemel Hempstead branch line which closed in sections in 1953, 1965 and 1968. This station was closed on 16 June 1947. Locomotive & General Railway Photographs.

In deep shadow a DMU has arrived at Sudbury on 4 October 1986. The original route with a terminal station diverged to the left beyond the footbridge. In 1990 the station was re-sited on to the original route and the track realigned. Maurice Dart

Plenty of tank wagons stand in the yard at Thames Haven when a special train worked by a DMU arrived on 21 May 2000. The crew are changing ends to work the next leg of the Railtour. The station closed to passengers in 1880. Maurice Dart

The 'Fletton Avoider' Railtour run by Badger Railtours on 2 November 1991 reached the stub of the LMS branch line from Cambridge to Bedford at Trumpington. The Great Northern Railway tracks to Hitchin are on the far left passing below an overline bridge. The track disappears into the grass beyond the train! Maurice Dart

On 2 November 1991 a Railtour reached Wisbech where four lines remained which merge to a single track to enter private premises. Passenger services here ceased on 9 September 1968 with freight traffic ceasing on 29 February 2004. Attempts are in progress to re-instate a passenger service to this location. Maurice Dart

MISCELLANEOUS RAILWAYS

This section contains a varied selection of industrial locos which worked in the area along with some preserved locos at some of the many locations in the area. Locations are arranged alphabetically.

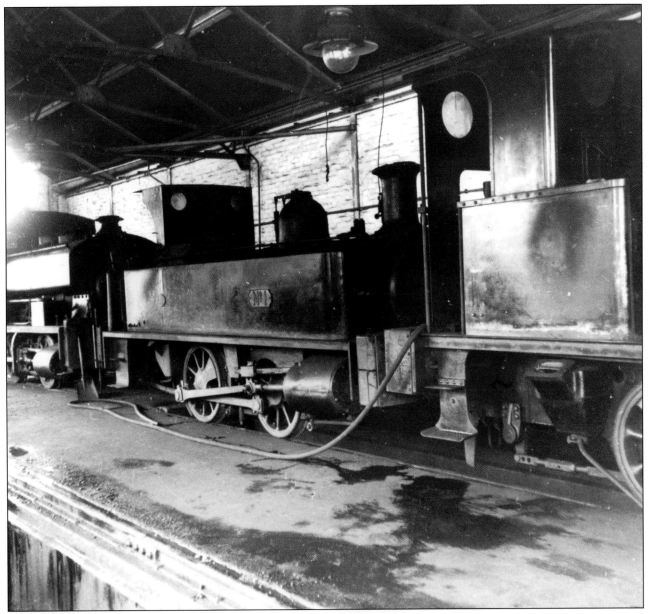

Centre in the photo is veteran 0-4-0T No.1 (Neilson 4397/1891) in a line of locos inside the shed at Beckton Gas Works in November 1959. Denis Richards

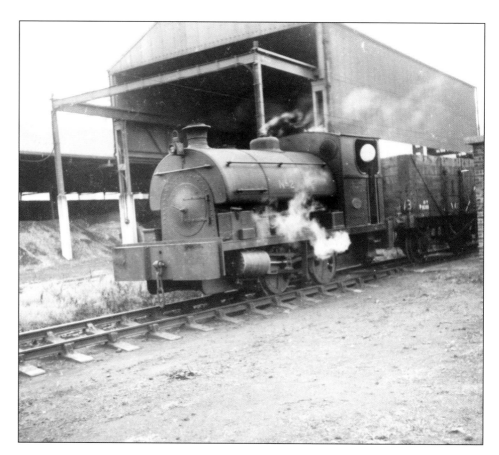

In November 1959 0-4-0ST No.2 (P2135/1953) shunts at Beckton Gas Works. The loco is coupled to 13T private owner 7-plank mineral wagon P16305. Denis Richards

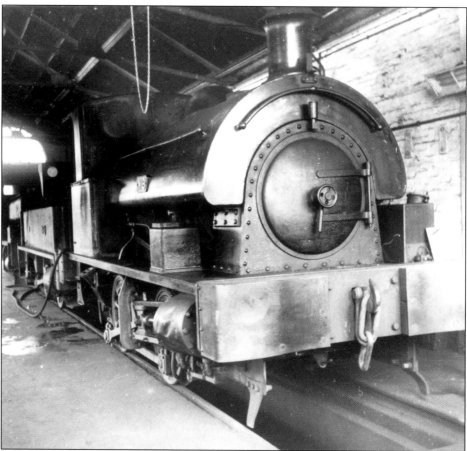

At the rear of a line of locos inside the shed at Beckton Gas Works in November 1959 is 0-4-0ST No.3 which was built by Hawthorn Leslie. Denis Richards

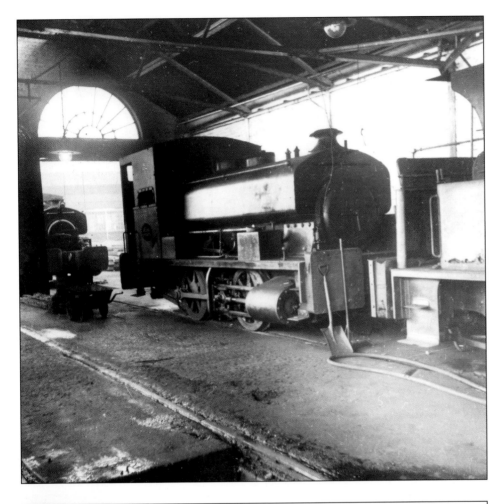

Just inside the loco shed at Beckton Gasworks in November 1959 is 0-4-0ST No.4 (AB 1666/1920) Denis Richards

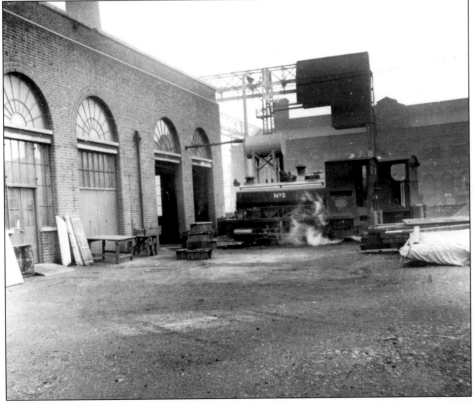

Two locos are outside the loco shed at Beckton Gasworks in November 1959. Nearest to the camera is 0-4-0ST No.5 (AB 1674/1920) Denis Richards

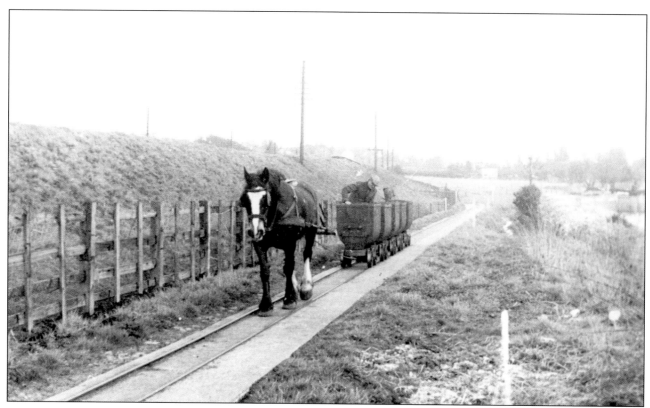

A horse trundles a train of five loaded cauldron wagons back towards the Gas Works along the 18-inch gauge tramway which ran from the works to Berkhamsted station on 9 April 1955. The main line is on the embankment to the left. R. M. Casserley

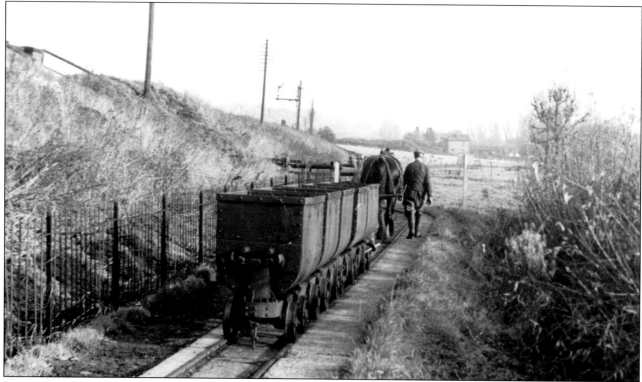

On 9 April 1955 five empty cauldron wagons return towards Berkhamsted Gas Works hauled by one horse. The 18-inch gauge line is about to pass below a bridge under the main line. R. M. Casserley

Standard gauge 2-10-0 NSB 5865 PEER GYNT (Schichau 4216/1944) is on display at Bressingham Gardens on 28 August 1983. R. J. Buckley

Beyer-Garratt 0-4-0 + 0-4-0T 6841 (BP 6841/1937) lurks inside one of the sheds at Bressingham Gardens on 14 August 1988. This loco has been named WILLIAM FRANCIS.

Maurice Dart

On the 1ft-11inch gauge line at Bressingham Gardens on 14 August 1988 is 0-6-0WT BRONLLWYD (HC 1643/1930). Maurice Dart

On 14 August 1988 1ft-11 inch 0-4-0ST GEORGE SHOLTO (HE 994/1909) stands on the headshunt ready to run around its train at Bressingham Gardens. This loco has been renamed BILL HARVEY. Maurice Dart

At Wroxham on the 15-inch gauge Bure Valley Railway on 10 August 1991 the 4w-4w DH built at the railway in 1989 couples to its train ready to depart to Aylsham. Maurice Dart

Inside the loco shed at Aylsham on the Bure Valley Railway on 10 August 1991 is No. 24 which had previously worked on the Fairbourne Railway. For some unaccountable reason I failed to record the builder's details and wheel arrangement of this loco and I have been unable to trace it in reference books. Maurice Dart

On 29 June 2001 2-6-4T No.1 WROXHAM BROAD rests inside the loco shed at Aylsham on the Bure Valley Railway. This loco which does not appear to be carrying its name had been rebuilt by Winsom in 1992 from a 2-6-2 DM (SO) loco built by Guest in 1964. R. J. Buckley

In a torrential downpour in the afternoon of 29 September 1990 during the West Anglia Rail Day 0-6-0T 656 THOMAS (Frisch 360/1949) visiting from the Nene Valley Railway prepares to propel a 2-car DMU shuttle out of Cambridge station's rarely used Platform 1 along the remaining stub of the branch line to Bedford. Maurice Dart

At Castle Hedingham on the Colne Valley Railway on 17 July 2002 is 0-6-0ST JUPITER (RSHN 7671/1950).

Planet 4wDM (FH 3147/1947) was almost hidden amongst rolling stock on the Colne Valley Railway at Castle Hedingham on 17 July 2002. Maurice Dart

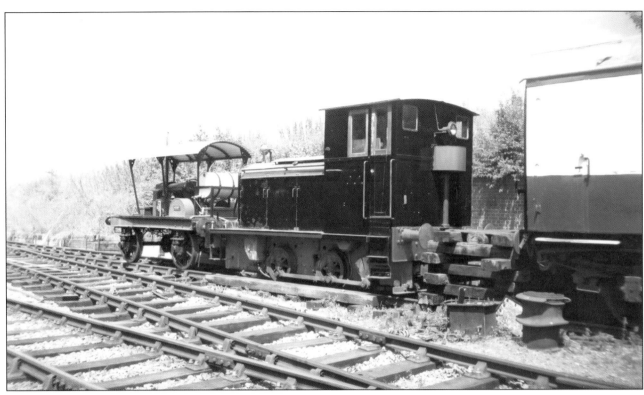

In the yard north of Castle Hedingham station on the Colne Valley Railway on 17 July 2002 are 4wD HENRY (Lake & Elliot/1924, rebuilt Ford TTC in 1997) and 0-4-0DM (RH 281266/1950). Maurice Dart

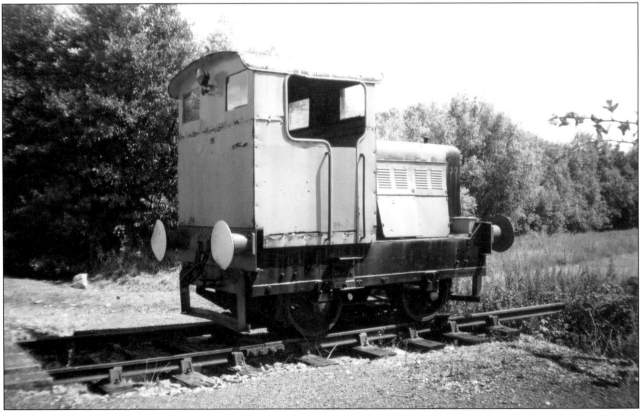

On the Colne Valley Railway at Castle Hedingham on 17 July 2002 is 4wDM 'YD No. 43' (RH 221639/1943). Maurice Dart

On 17 July 2002 on the Colne Valley Railway at Castle Hedingham is 0-4-0ST VICTORY (AB 2199/1945). Maurice Dart

Against the stop block at Castle Hedingham station on the Colne Valley Railway on 17 July 2002 is 0-4-0ST No.1 (HL 3715/1928). Maurice Dart

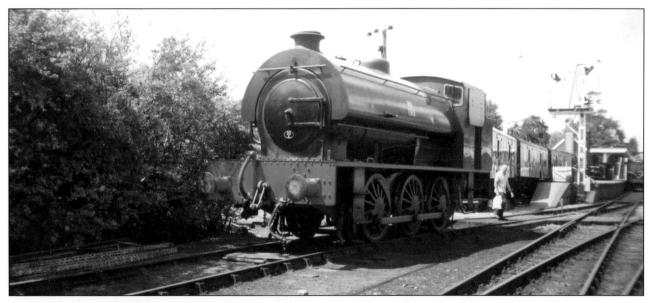

A member of staff was surprised to find me wandering around the Colne Valley Railway taking photos on 17 July 2002 which was a non-running day when I visited Castle Hedingham station. On arrival I found a member of staff, and following a chat I paid the normal site admission fee and was given the 'Freedom of the site and line' with permission to walk everywhere I wished. When the visit ended I was told to walk the length of the line to a level crossing and directed how to reach Castle Hedingham village. None of this would have been permitted on an operational day. Near the station is 0-6-0ST 'WD 190' (HE 3790/1952) with the earlier-mentioned staff member staring at me in a very surprised manner! Maurice Dart

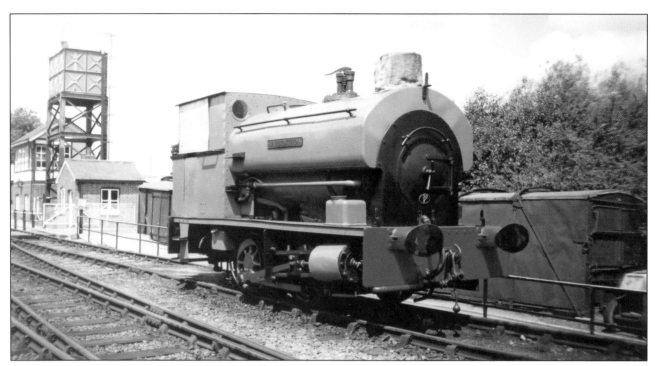

At Castle Hedingham on the Colne Valley Railway on 17 July 2002 is 0-4-0ST BARRINGTON (AE 1875/1921).
Maurice Dart

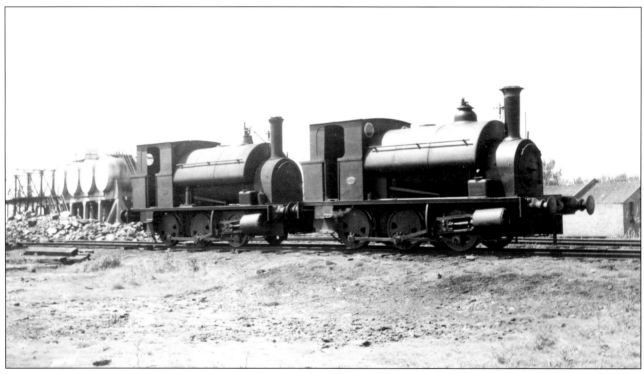

In 1901 the standard gauge Corringham Light Railway opened its 2½ mile line from Corringham to Kynoch Town north of Shell Haven and Thames Haven, for goods traffic on 1 January and to passenger trains on 29 June. The eastern terminus was renamed Coryton in 1921. All traffic ceased on 2 March 1952. Two 0-6-0STs in the shed yard at Coryton on 3 June 1950 are AE 1771/1917 on the right and AE 1672/1914 on the left. Ernie Foster

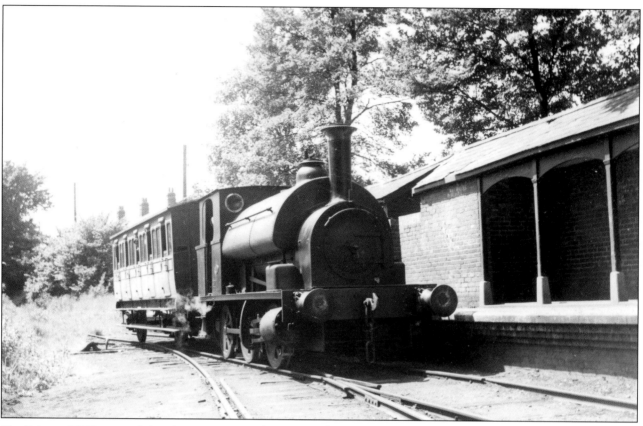

On 3 June 1950 a special train was run on the Corringham Light Railway for the Railway Correspondence & Travel Society. Hauled by 0-6-0ST AE 1771/1917 the train which consisted of an ex LTSR 1876 vintage 4-wheeled carriage is almost at the grass-covered end of track at Corringham. Ernie Foster

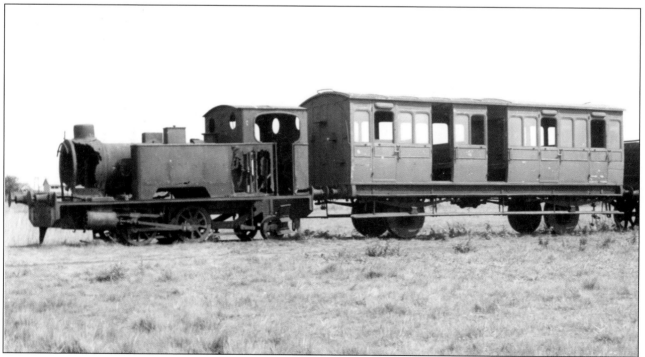

The 1876 built ex LTSR 4-wheeled coach and 0-4-2T KYNITE (KS 692/1900) at Coryton on the Corringham Light Railway on 3 June 1950. Ernie Foster

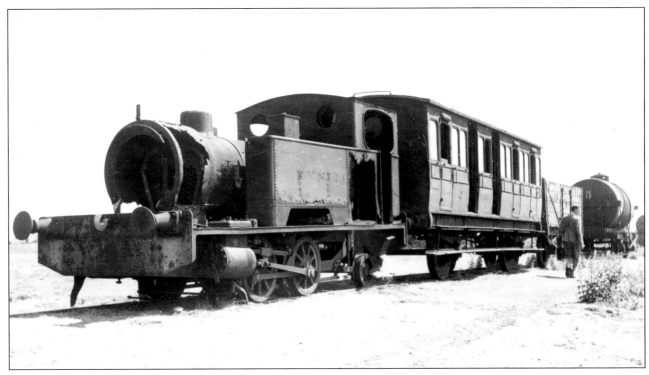

Another view of 0-4-2T KYNITE (KS 692/1900) at Coryton on the Corringham Light Railway on 3 June 1950 shows the very poor state of the loco with large holes. The LTSR 1876 built 4-wheeled coach is to its rear. Behind the coach are Cory Bros. open wagon 1233 and Cory Bros. oil tank wagon No.12. Ernie Foster

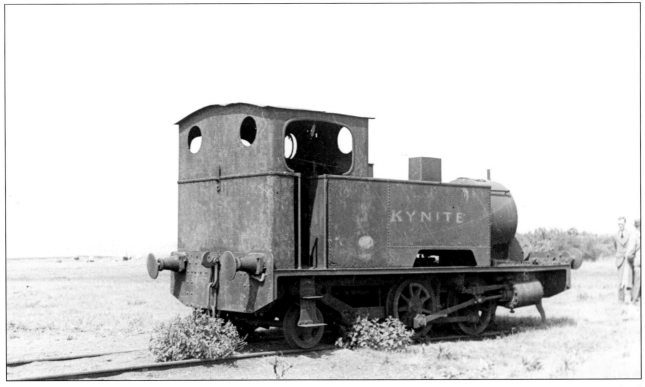

At Coryton on the Corringham Light Railway on 3 June 1950 is 0-4-2T KYNITE (KS 692/1900) which had become derelict in 1937.

The Mid-Norfolk Railway Society's site at County School station contained 0-4-0DM No.1 (RH 497753/1963) on 10 August 1991. This loco has been named COUNTY SCHOOL.
Maurice Dart

County School at the Mid-Norfolk Railway Society's site on 10 August 1991 with 0-4-0DH No.2 (RSHD 8368/1962/WB 3213/1962). This station is north of Dereham. Maurice Dart

Two 2ft gauge locos are at the East Anglian Railway Museum at Carlton Colville near Lowestoft on 13 August 1988. On the left is 4wDM No.2 (MR 5912/1934) with 4wDM No.4 (RH 177604/1936) moving over the loop.
Maurice Dart

An unidentified 0-6-0T masquerading as Thomas at Mangapps Farm, Burnham-on-Crouch on 15 July 2002. Maurice Dart

At Mangapps Farm on 15 July 2002 is BR lookalike 0-6-0DM 11104 (VF D78/1948/DC 2252/1948). This loco was not ex BR. Maurice Dart

Lurking inside one of several sheds at Mangapps Farm on 15 July 2002 is 0-6-0ST (FW 358/1878).

Three locos stand in the yard on the North Norfolk Railway at Weybourne on 5 October 1986. Nearest to the camera is 0-6-0ST EDMUNDSONS ((AB 2168/1943). This loco is preserved at the Rushden station site. Dismantled is another unidentified 0-6-0ST with a 4wDH at the rear. To the right is ex SR Brake van 55167.

Maurice Dart

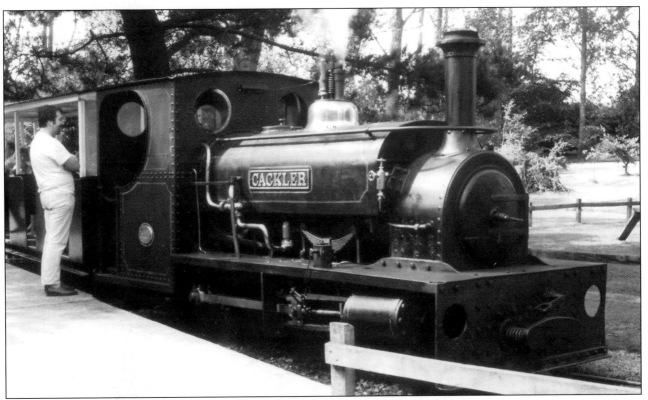

At the G. T. Cushing Steam Museum at Thursford Green, near Fakenham on 15 August 1988 is 1ft-10¾ inch gauge 0-4-0ST CACKLER (HE 671/1898) which operated a train over the circuit. Maurice Dart

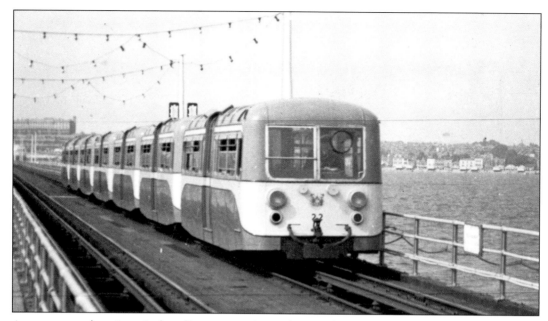

A seven-car electric train heading outwards on the Southend Pier Railway in the late1950s. At this time the line was laid to a gauge of 2ft-6inches but this has been changed to 3ft.
Edward Dart

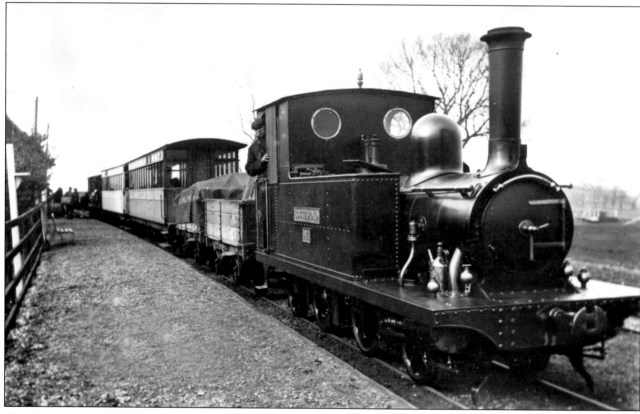

The 3ft gauge Southwold Railway, which ran for 8½ miles from Halesworth, between Saxmundham and Beccles, to Southwold opened in September 1879 and closed completely in April 1929. 2-4-2T No. 1 SOUTHWOLD (SS 3913/1893) has arrived at Halesworth with a mixed train in the mid-1920s. Passengers are collecting their baggage from the covered van at the rear of the train. The 6-wheeled 6 vestibuled carriages were built to Cleminson's Patent design for the Woosung Tramway in China.

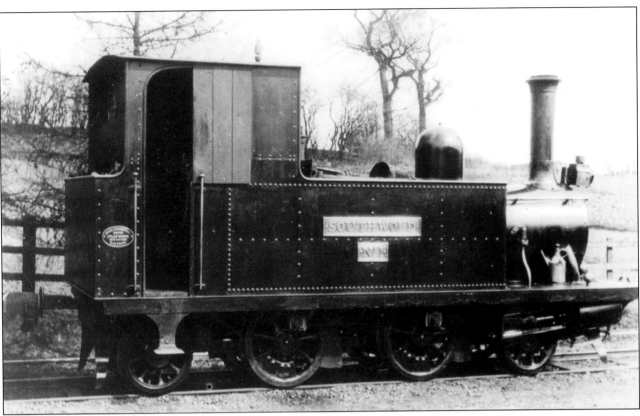

A close-up side view of Southwold Railway 2-4-2T No.1 SOUTHWOLD (SS 3913/1893), possibly at Blythburgh in the 1920s. Note the improvised wooden shutters added to the cab window to afford the crew better protection from adverse weather.

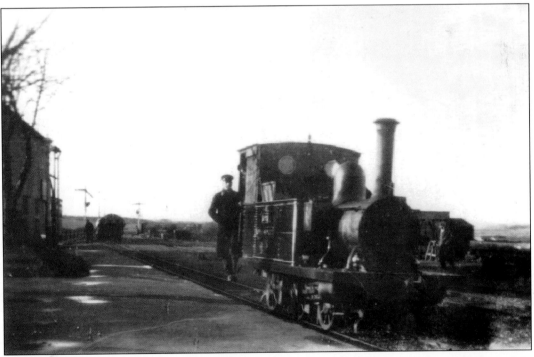

Southwold Railway 2-4-0T No.2 HALESWORTH (SS 2849/1879) running around its train after arriving at Halesworth in March 1926. Note the signal just visible in the distance fitted with two arms, one for each direction. E. Cotton

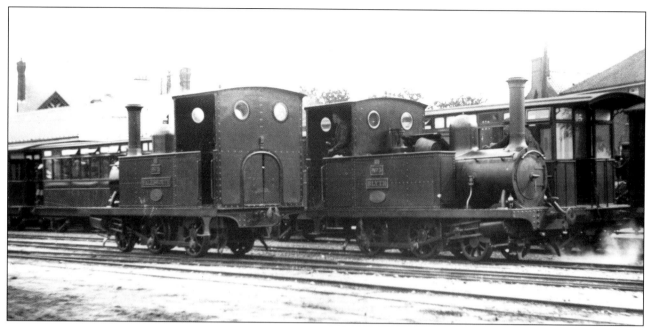

Southwold Railway 2-4-0Ts No.2 HALESWORTH (SS 2849/1879) and No.3 BLYTH (SS 2850/1879) stand alongside carriages at Southwold station on 10 September 1910. The Locomotive Club of Great Britain/Ken Nunn Collection

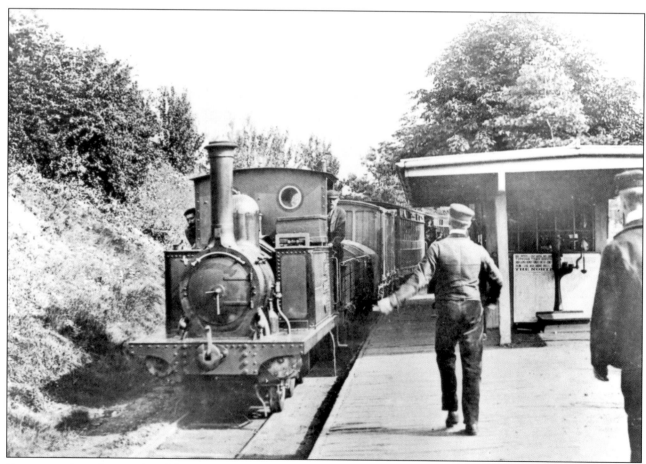

Passengers board a Southwold Railway train hauled by 2-4-0T No.3 BLYTH (SS 2850/1879) at Halesworth in the early 1920s.

A rather murky photo of Southwold Railway 0-6-2T No.4 WENHASTON (MW 1845/1916) and 2-4-0T No.3 BLYTH (SS 2850/1979) at Southwold in March 1926. E. Cotton

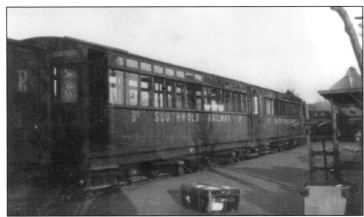

A Southwold Railway third class carriage coupled to a 1st/2nd class composite carriage at Southwold in March 1926. E. Cotton

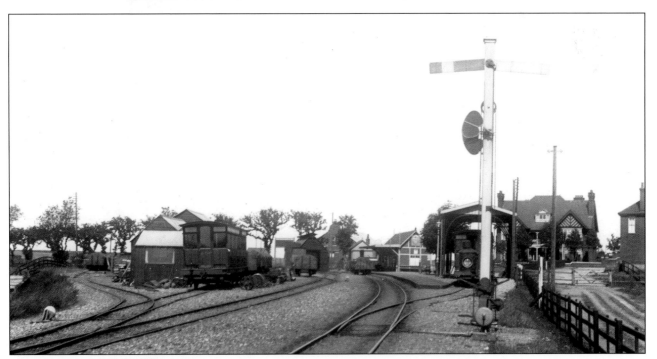

The Southwold Railway loco shed is in the centre of this photo of Southwold station in July 1911. The bi-directional signal is prominent. The Locomotive Club of Great Britain/Ken Nunn Collection

On the 10¼ inch gauge Wells & Walsingham Light Railway a crowded train hauled by Beyer-Garratt 2-6-0 + 0-6-2T No. 3 NORFOLK HERO passes 6wDH No.2 (now named WEASEL) at the approach to Wells-Next-The-Sea station on 15 August 1988. Maurice Dart

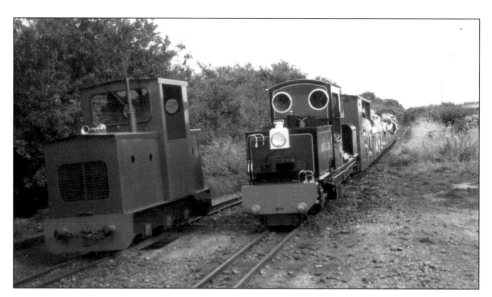

On 15 August 1988 on the 12¼ inch gauge Wells Harbour Railway a train hauled by 4wDM ALPHA awaits departure from Wells Town. Maurice Dart

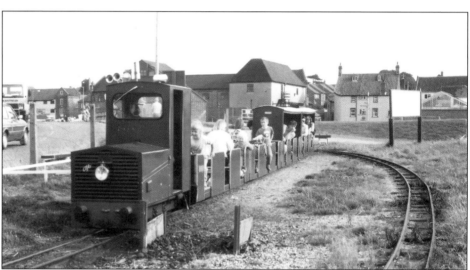

At the outer end of the Wells Harbour Railway 0-4-2 EDMUND HANNAY rests outside the loco shed at Pinewoods on 15 August 1988. Maurice Dart

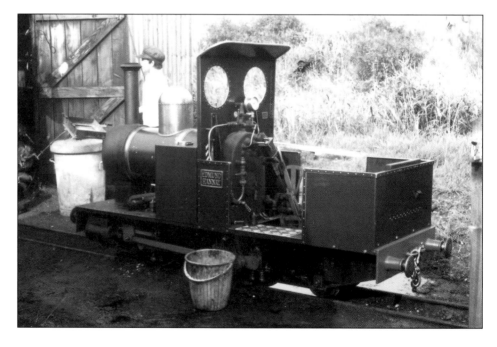

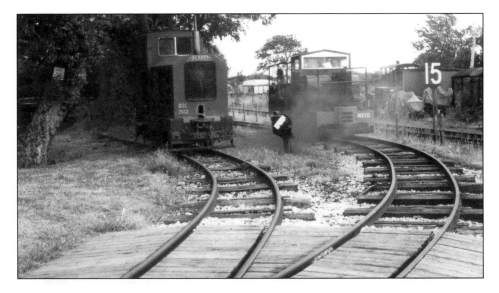

On the 1ft-11½ inch gauge Yaxham Light Railway 4DM DOE 3982 (FH 3982/1962) stands in a siding as a train passes hauled by 4wDM OUSEL (MR 7153/1937) on 10 August 1991. This railway has lines on each side of the standard line which can be seen to the right of the locos. The loco yard is in the right background.
Maurice Dart

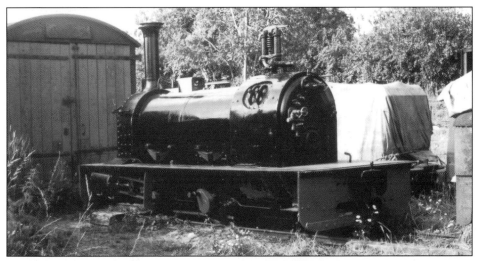

On 10 August 1991 partly dismantled in the loco yard at Yaxham on the Light Railway is 0-4-0ST No.16 ELIN (HE 705/1899). On the left is the end of the grounded body of an ex-GWR MOGO Motor Car van.
Maurice Dart

On 10 August 1991 0-4-0VBT No.1 (Potter/1970) was in a most awkward spot in the loco yard on the Light Railway at Yaxham. To record it necessitated aiming the camera partly into the bright sunlight.
Maurice Dart

LOCATION INDEX